PHOTOSECRETS
WASHINGTON DC

WHERE TO TAKE PICTURES

BY
ANDREW HUDSON

"A good photograph
is knowing where to stand."
— Ansel Adams

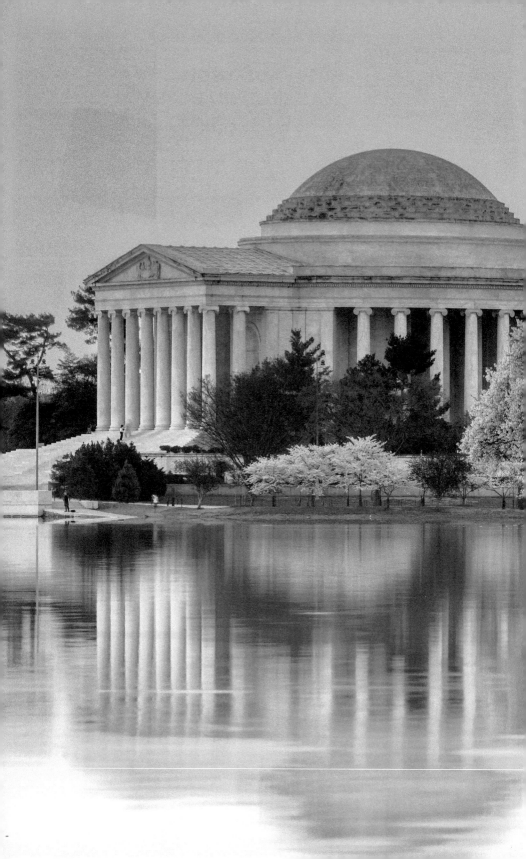

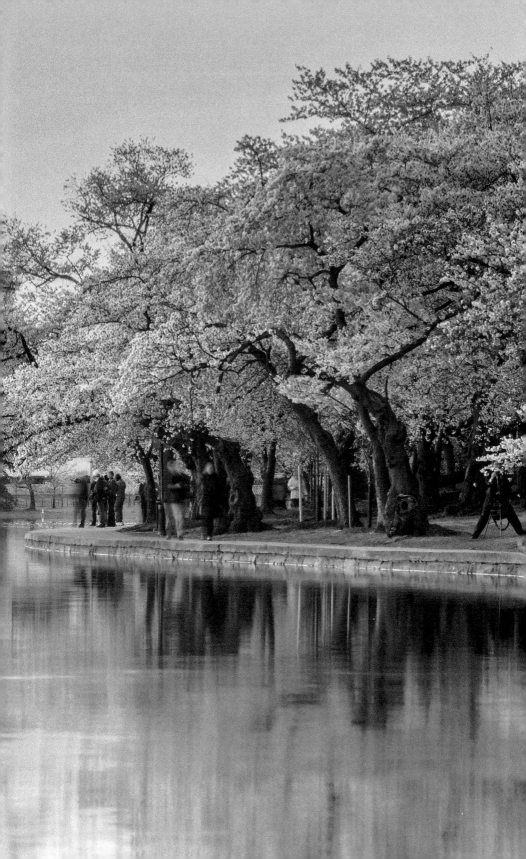

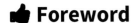

A GREAT TRAVEL photograph, like a great news photograph, requires you to be in the right place at the right time to capture that special moment. Professional photographers have a short-hand phrase for this: "F8 and be there."

There are countless books that can help you with photographic technique, the "F8" portion of that equation. But until now, there's been little help for the other, more critical portion of that equation, the "be there" part.

To find the right spot, you had to expend lots of time and shoe leather to research the area, walk around, track down every potential viewpoint, see what works, and essentially re-invent the wheel.

In my career as a professional travel photographer, well over half my time on location is spent seeking out the good angles. Andrew Hudson's PhotoSecrets does all that legwork for you, so you can spend your time photographing instead of wandering about. It's like having a professional location scout in your camera bag. I wish I had one of these books for every city I photograph on assignment.

PhotoSecrets can help you capture the most beautiful sights with a minimum of hassle and a maximum of enjoyment. So grab your camera, find your favorite PhotoSecrets spots, and "be there!"

Bob Krist has photographed assignments for *National Geographic*, *National Geographic Traveler*, *Travel/Holiday*, *Smithsonian*, and *Islands*. He won "Travel photographer of the Year" from the Society of American Travel Writers in 1994, 2007, and 2008 and today shoots video as a Sony Artisan Of Imagery.

For *National Geographic*, Bob has led round-the-world tours and a traveling lecture series. His book *In Tuscany* with Frances Mayes spent a month on *The New York Times'* bestseller list and his how-to book *Spirit of Place* was hailed by *American Photographer* magazine as "the best book about travel photography."

After training at the American Conservatory Theater, Bob was a theater actor in Europe and a newspaper photographer in his native New Jersey. The parents of three sons, Bob and his wife Peggy live in New Hope, Pennsylvania.

☕ Contents

📍 Washington DC

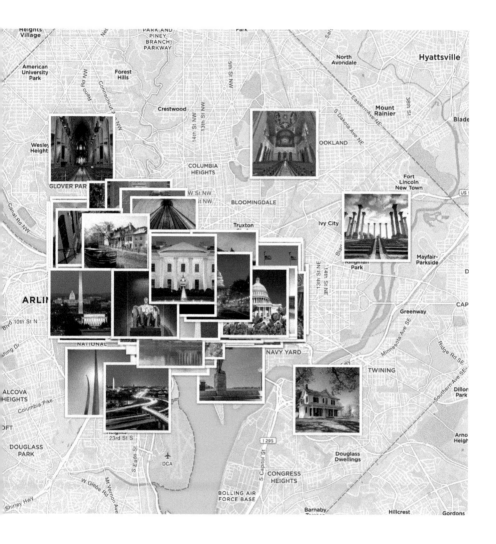

📍 US Capitol area

The **United States Capitol** is home to the country's legislative branch of government and occupies the original geographical center of Washington, D.C. The Capitol Grounds provide a variety of views of the east and west fronts and other features.

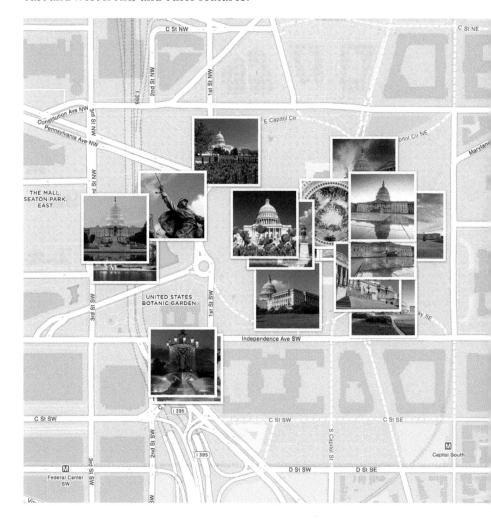

♀ White House area

The **White House** is home to the President of the United States and lies northwest of the United States Capitol. The surrounding President's Park includes Lafayette Park to the north and the South Lawn and The Ellipse to the south.

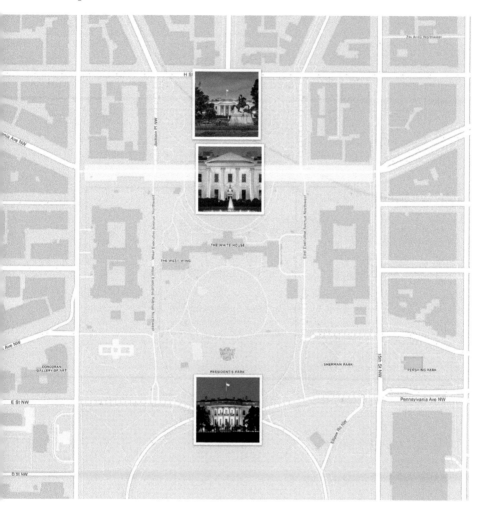

📍 Washington Monument area

The **Washington Monument** is an obelisk south of the White House in West Potomac Park, at the center of the parkland that is often called the National Mall.

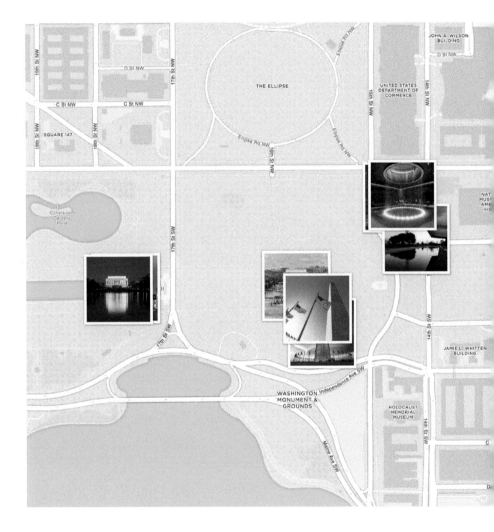

📍 National Mall

The **National Mall** (proper) is a landscaped park between the U.S. Capitol and the Washington Monument. It is flanked by eleven of the 19 Smithsonian Institution museums, and the National Gallery of Art.

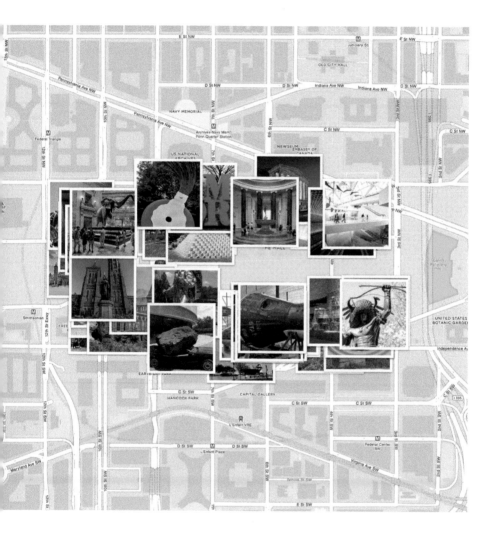

📍 Lincoln Memorial area

The **Lincoln Memorial** is west of the Washington Monument, across a long reflecting pool. Nearby are the Vietnam Veterans Memorial and the Korean War Veterans Memorial.

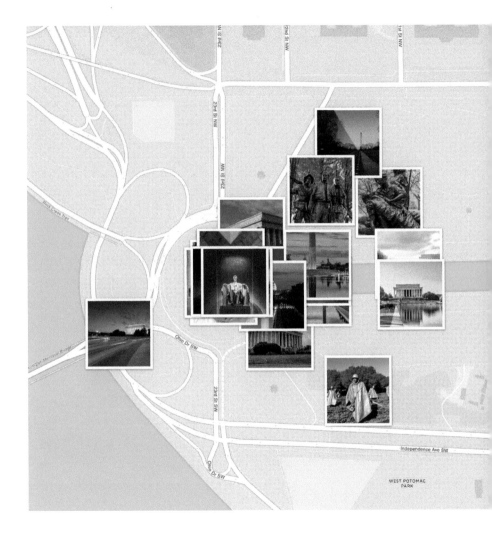

📍 Jefferson Memorial area

The **Jefferson Memorial** lies southeast of the Lincoln Memorial, on the shore of the Tidal Basin. Nearby, among cherry trees which blossom in the spring, are memorials to Martin Luther King Jr., Franklin Delano Roosevelt and George Mason.

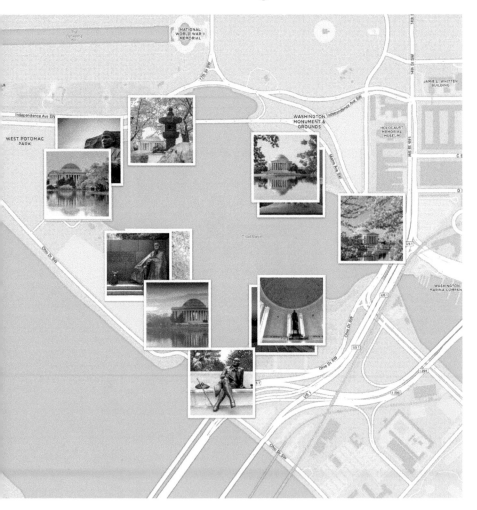

♥ Capitol Hill area

Capitol Hill is east of the U.S. Capitol and includes the Library of Congress and the Supreme Court of the United States. Nearby is Senate Park and Union Station.

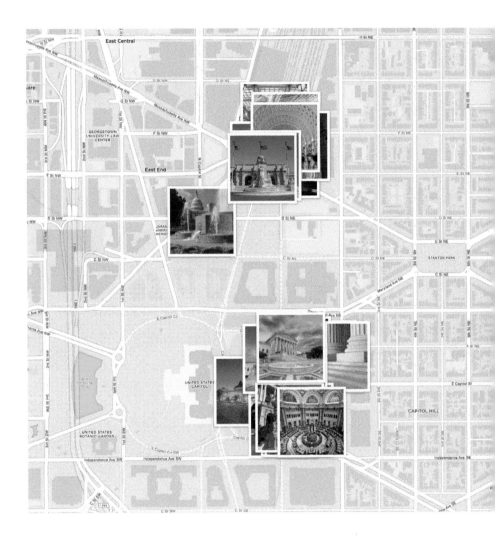

♥ Penn Quarter area

Penn Quarter is between the U.S. Capitol and the White House, along Pennsylvania Avenue. The area includes Chinatown and Federal Triangle.

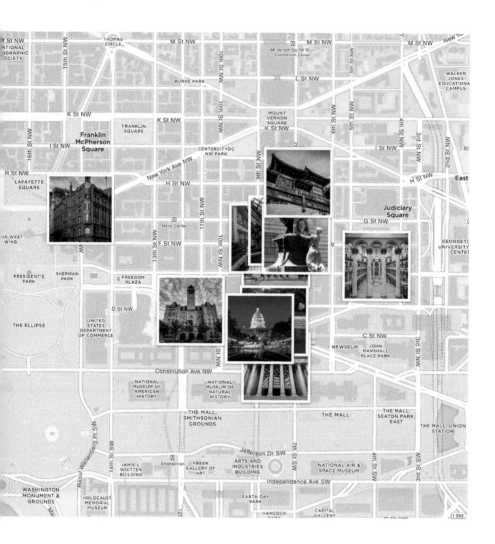

📍 Georgetown

Georgetown is a historic neighborhood which predates Washington DC by 40 years. Founded as a port in 1751, the area includes Georgetown University (1789) and the C&O Canal (1828).

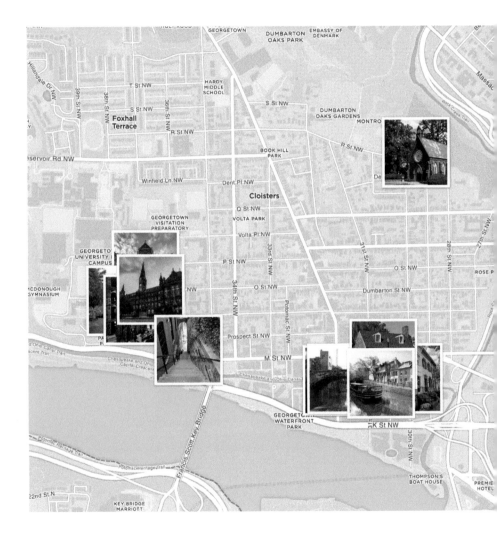

📍 Outer Washington

Elsewhere in Washington, D.C. are the National Zoo, the National Cathedral, the National Capitol Columns, the embassy areas of Foggy Bottom and Dupont Circle, a memorial to the Titanic, and the Frederick Douglass National Historic Site.

📍 Arlington area

Arlington County in Virginia is on the west side of the Potomac River and is home to Arlington National Cemetery. There are good skyline shots from here and neighboring Columbia Island.

ⓘ Introduction

Washington, D.C. is the nation's capital and beckons your camera with the stars of the news — the U.S. Capitol, the White House, and the Supreme Court. These three buildings represent the three branches of U.S. government; legislative, executive and judicial. They are connected by landscaped parkland with photogenic monuments and reflecting pools, all offering classic postcard views just for you.

Following the American Revolution in 1783, the U.S. Congress was forced to flee the capital of Philadelphia by a mob of unpaid soldiers. As a result, in Article One of the United States Constitution of 1787, Congress gave itself the power to create its own "District (not exceeding ten Miles square) as ... the Seat of the Government of the United States..." which, James Madison argued, needed to be distinct from the states. Madison, Thomas Jefferson, and Alexander Hamilton agreed on a Southern location for the federal capital, on land offered by the states of Maryland and Virginia along the Potomac River.

President George Washington proclaimed in 1791 that "Jones's point... in Virginia" would be the southern point and a diamond-shaped area measuring 10 miles (16 km) on each side was surveyed, with the U.S. Capitol to be in the center, on Maryland's side. Wary of abolitionists in Congress, the pro-slavery Virginia area was taken back in 1846, leaving the current 69 square miles (179 km2).

In 1871, the cities of Georgetown and Washington were merged with the Territory of Columbia so that today's city, while legally named the District of Columbia, is known as Washington, D.C.

The major sights were planned to showcase a grand national capital. In 1791, President Washington commissioned Pierre (Peter) Charles L'Enfant, a French-born architect and city planner, to design the new capital. Based on plans of cities such as Paris, Amsterdam, Karlsruhe, and Milan that Thomas Jefferson had sent to him, the L'Enfant Plan featured broad streets and avenues radiating out from a garden-lined "grand avenue" leading west from the United State Capitol.

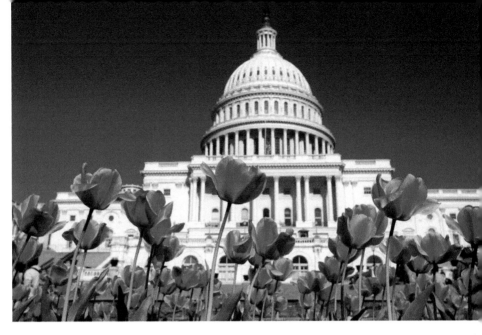

The **United States Capitol**, often called the Capitol Building, is the home of the U.S. Congress, the legislative branch of the U.S. federal government. Begun in 1793, the initial structure opened in 1800 and was burned, rebuilt and expanded through to 1904.

The Capitol is built in a distinctive neoclassical style, evoking the ideals from ancient Greece and Rome that guided the nation's founders as they framed their new republic.

The Senate occupies the north wing and the House of Representatives in the south wing. The two meet in the center, physically if not always politically.

The **West Front** (above) faces the Capitol Grounds, the Capitol Reflecting Pool and the afternoon sun, perfect for photography.

✉ **Addr:**	US Capitol, Washington DC 20004	♀ **Where:**	38.889791 -77.00901	
☼ **When:**	Morning	◉ **Look:**	West	
W **Wik:**	United_States_Capitol			

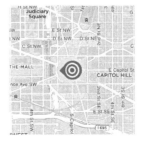

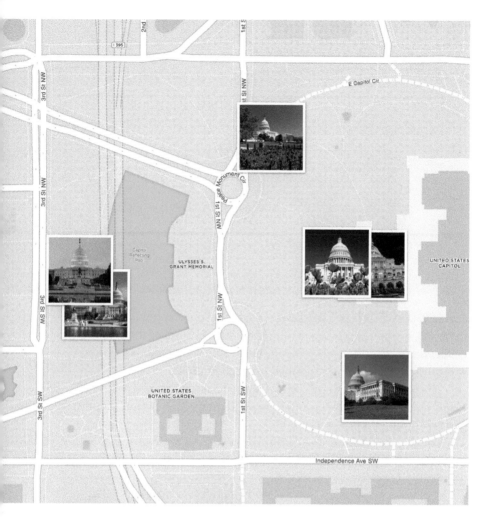

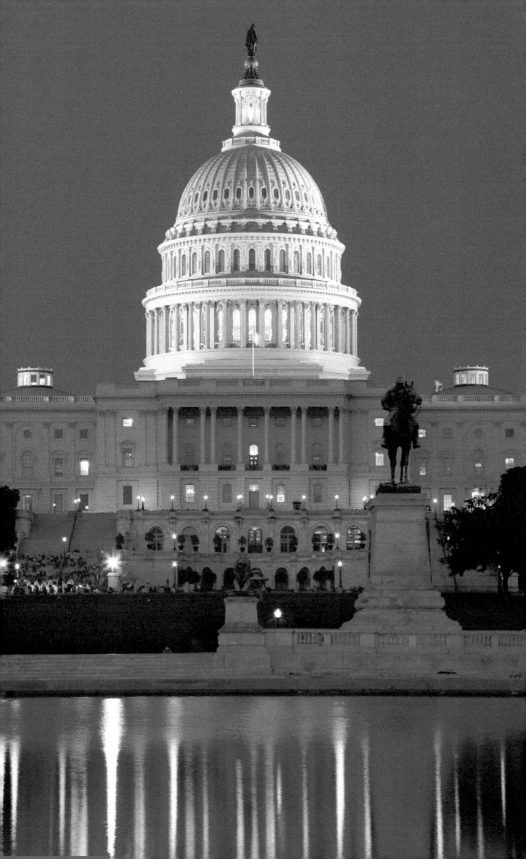

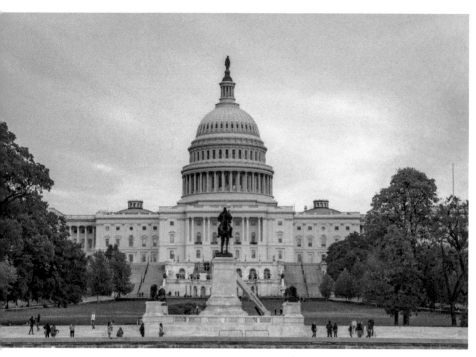

Grant Memorial and Capitol Reflecting Pool from Union Square.

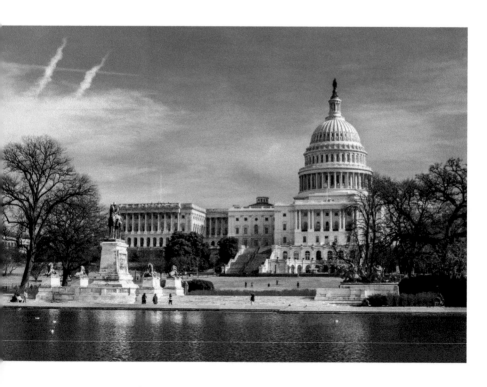

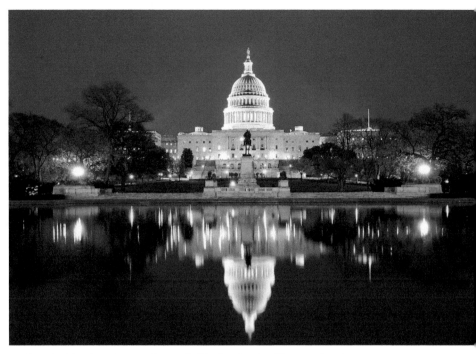

Dusk and night views across the Capitol Reflecting Pool from Union Square.

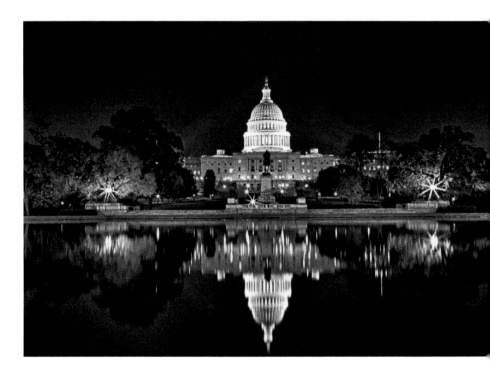

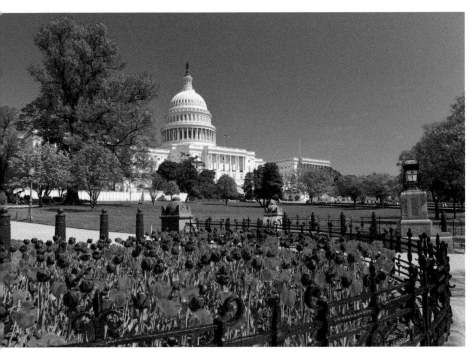

Above: The Capitol Grounds have several flower beds which make colorful foregrounds in the spring. Below: The West Terrace has a fountain and, for some reason, potted palm trees.

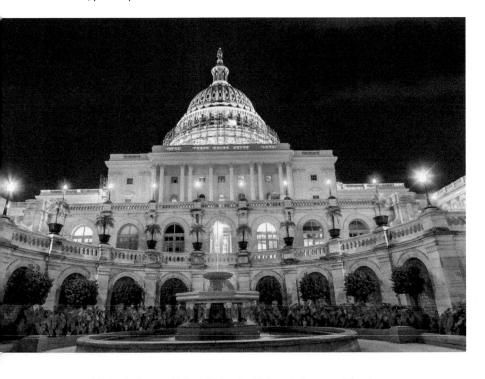

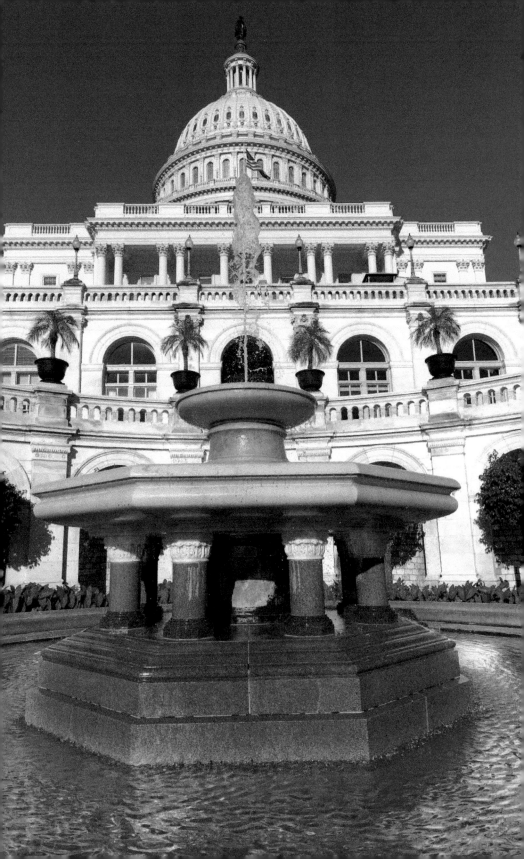

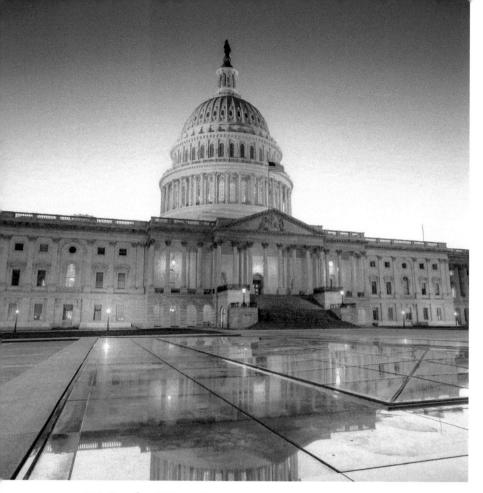

The **US Capitol East Front** is the main entrance, intended for the reception of visitors and dignitaries. The "wedding-cake style" dome was added in 1863, the Greek-style portico dates to 1904, and the underground Capitol Visitor Center opened in 2008.

✉ **Addr:**	US Capitol, Washington DC 20004	📍 **Where:**	38.889776 -77.007315	
◐ **When:**	Morning	👁 **Look:**	West	
W **Wik:**	United_States_Capitol			

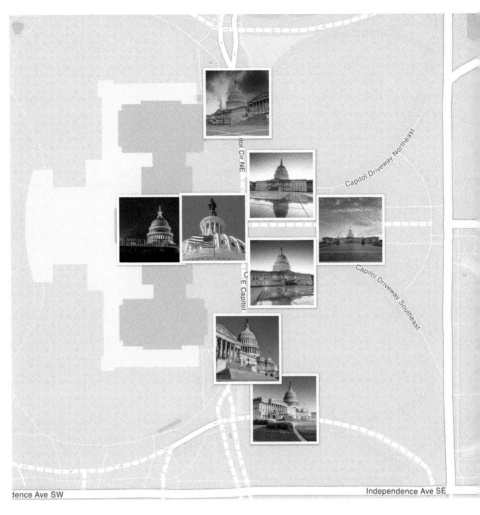

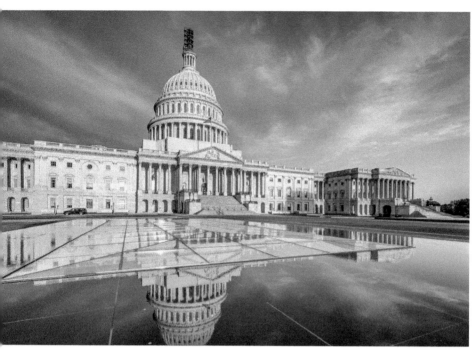

A pair of skylights on the ground provide light to the underground Visitors Center and make useful reflecting pools. South skylight in the morning (above) and north skylight at dusk (below).

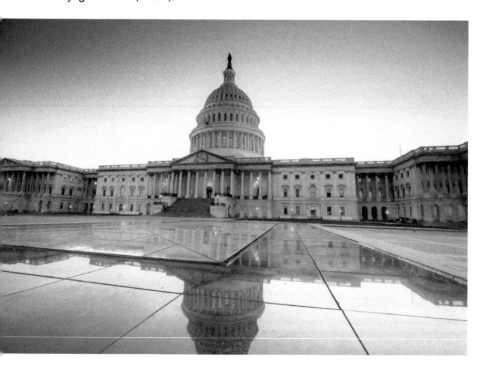

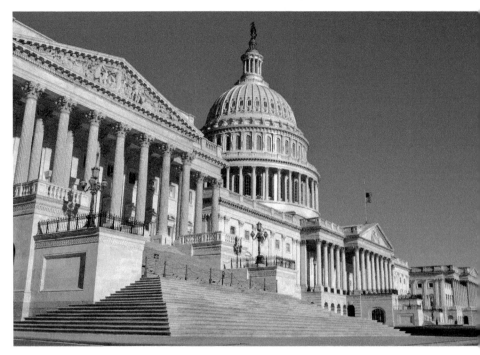

There are three entrances on the east front — one for the House of Representatives (above) to the south, one for the Grand Rotunda (left) in the center, and one for the Senate (north).

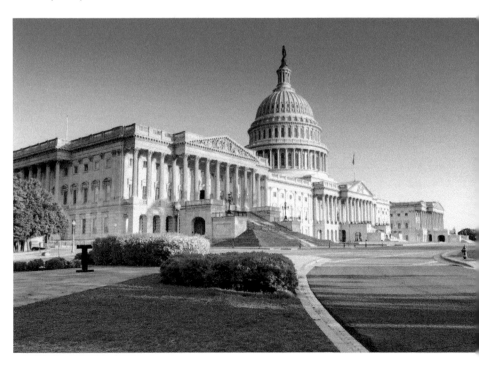

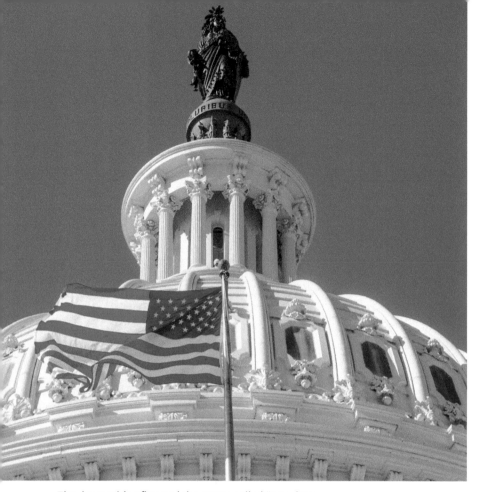

The dome with a flag and the statue called "Freedom.

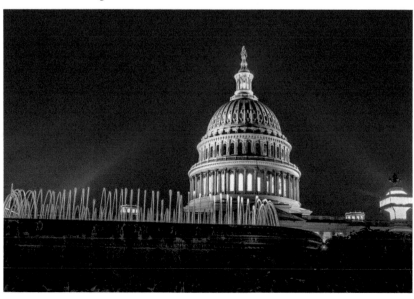

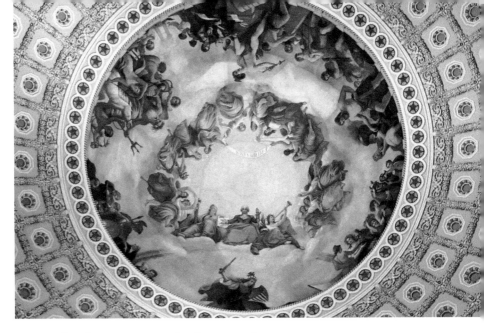

The **United States Capitol rotunda** is a circular ceremonial space described as its "symbolic and physical heart."

Built 1818–1824 and based on the Pantheon in Rome, the rotunda is encircled with paintings and sculptures depicting significant people and events in the nation's history. A statue of George Washington makes a particularly good foreground.

The dome was enlarged from 1857–1866 and consists of an inner and outer dome, with a canopy suspended between them that is visible through an oculus at the top of the inner dome. The canopy is decorated with a large fresco by Greek-Italian Constantino Brumidi called *The Apotheosis of Washington*, depicting George Washington sitting exalted amongst the heavens. So you can photograph Washington below himself in heaven.

✉ **Addr:**	US Capitol, Washington DC 20016	⚲ **Where:**	38.89000 -77.009000	
❓ **What:**	Rotunda	◕ **When:**	Afternoon	
👁 **Look:**	North	W **Wik:**	United_States_Capitol_rotunda	

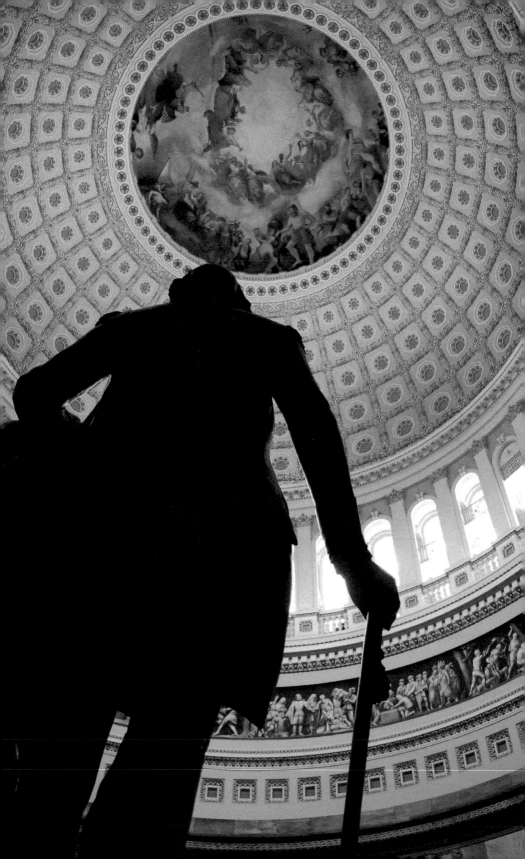

The **Ulysses S. Grant Memorial** honors the Civil War general and 18th President and sits below the west front of the Capitol.

The 252 feet (77 m) long platform features a statue of Grant looking west toward the Lincoln Memorial, which honors Grant's wartime president, Abraham Lincoln. Flanking pedestals hold statues of protective lions, Union soldiers and artillery.

See if you can find the sculptor, Henry Shrady, who depicted himself in the north Cavalry Group, about to be trampled by horses. This was prophetic as, after spending twenty years working on the memorial, Shrady died, stressed and overworked, two weeks before its dedication in 1922.

✉ **Addr:**	Union Square, Washington DC 20016	♀ **Where:**	38.890149 -77.013109
❓ What:	Memorial	☾ **When:**	Afternoon
👁 **Look:**	East	W **Wik:**	Ulysses_S._Grant_Memorial

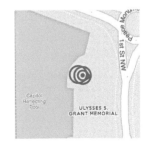

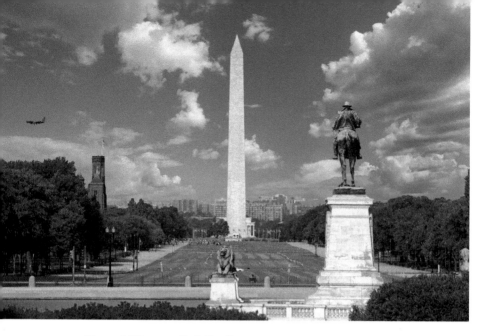

The **Grant Memorial facing west**, with the National Mall, the Washington Monument, the Lincoln Memorial (partial view) and, to the left in red, the Smithsonian Castle. This is taken from the West Terrace of the Capitol and is best photographed in the morning, with light coming from the east.

The Grant Memorial is part of a three-piece group with the Peace Monument (1877 by Franklin Simmons) to the north and the James A. Garfield Monument (1887 by John Quincy Adams Ward).

The Capitol Grounds were designed by noted American landscape architect Frederick Law Olmsted, who planned the expansion and landscaping performed from 1874 to 1892, including a hexagonal brick Summer House in the north.

✉ **Addr:**	US Capitol, Washington DC 20016	♀ **Where:**	38.889596 -77.010357
☾ When:	Morning	**👁 Look:**	West
↔ **Far:**	2.15 km (1.34 miles)		

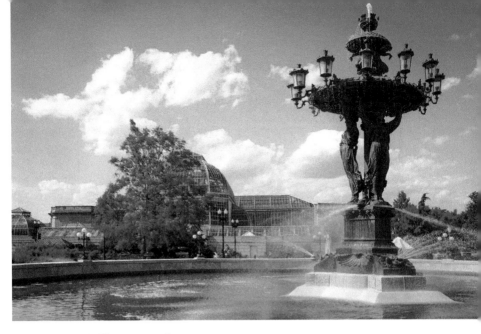

The **Bartholdi Fountain** is a monumental public fountain, designed by Frédéric Auguste Bartholdi, who later created the Statue of Liberty. The 30-foot-tall fountain from 1876 features three eleven-feet-tall nymphs holding the upper basin, plus turtles, cherubs, frogs, fish, and twelve lamps.

The surrounding Bartholdi Park is part of the United States Botanic Garden located on the grounds of the United States Capitol.

✉ **Addr:**	Bartholdi Park, Washington DC 20024	♀ **Where:**	38.886916 -77.012524
❓ **What:**	Fountain	☽ **When:**	Morning
👁 **Look:**	North-northwest	W **Wik:**	Bartholdi_Fountain

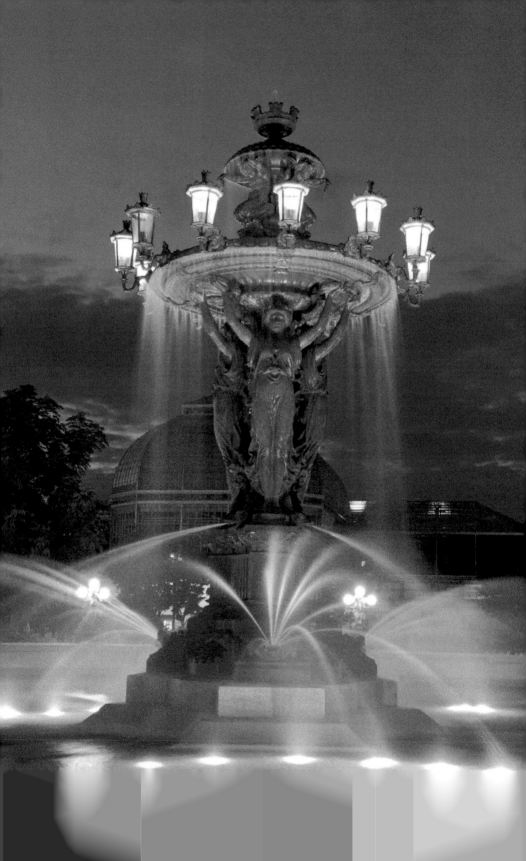

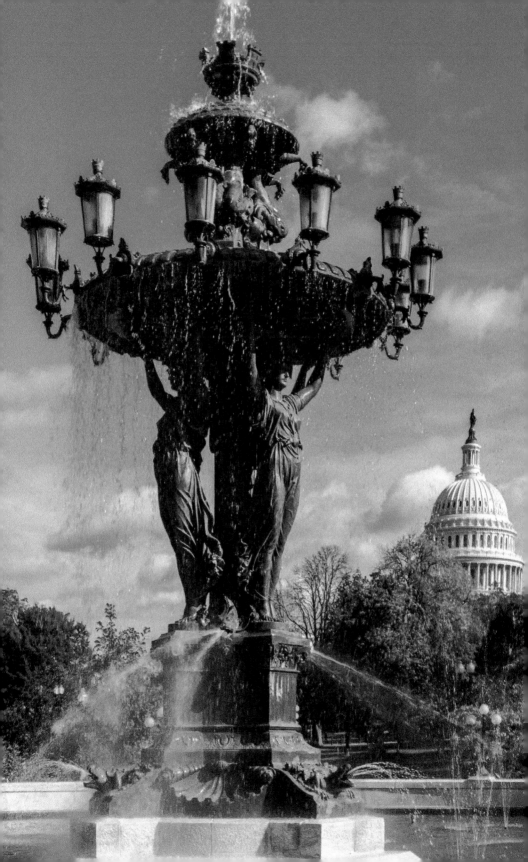

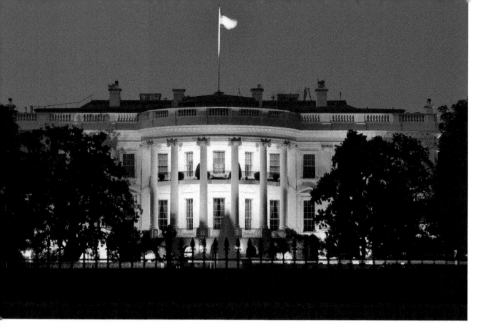

The **White House** is the official residence and workplace of the President of the United States. Every President since Washington has resided here, since 1800. It is located 1.6 miles (2.5 km) northwest of the Capitol, at the famous address of 1600 Pennsylvania Avenue NW.

Because of crowding within the executive mansion itself, all work offices are now in the adjoining West Wing extension, including the famous Oval Office. Unfortunately, the Oval Office is not visible to the public, hidden by trees to the left of these pictures. What you can see is the semi-circular south portico added in 1824, which fronts the Diplomatic Reception Room (ground floor) and Blue Room (on the State Floor) with the Truman Balcony.

✉ **Addr:**	1600 Pennsylvania Ave NW, Washington DC 20500	♀ **Where:**	38.8977 -77.0365
❓ **What:**	Building	◑ **When:**	Afternoon
👁 **Look:**	North	W **Wik:**	White_House

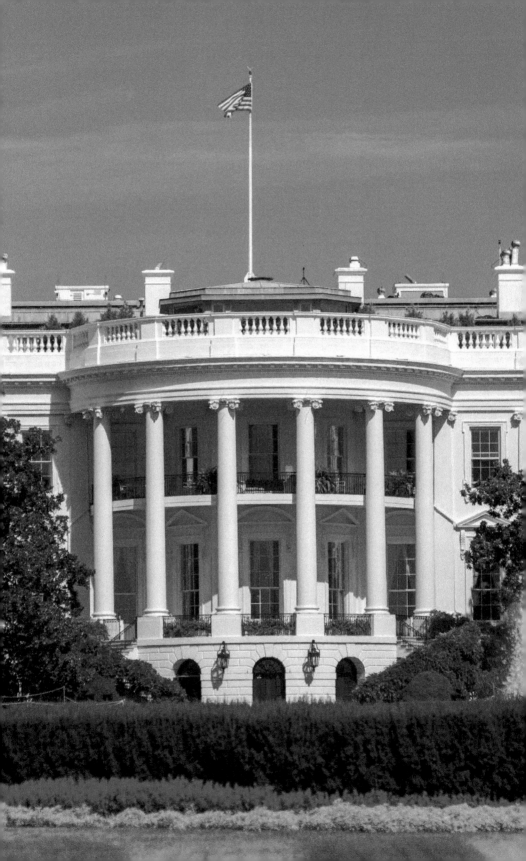

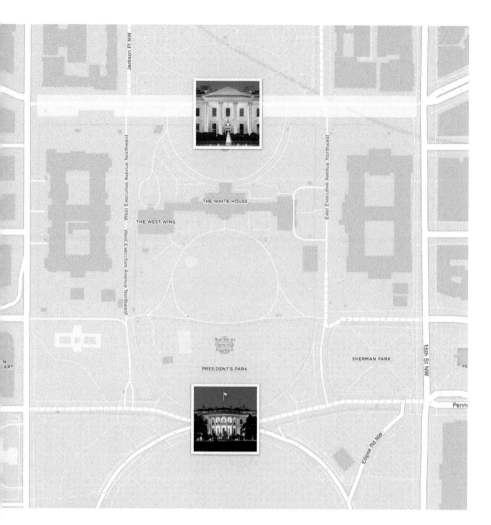

 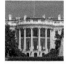

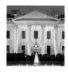

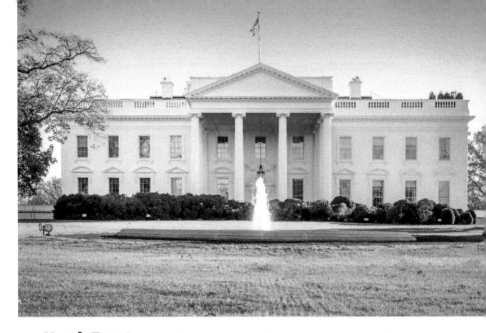

The **North Front** of the White House is the principal façade, facing a fountain and Lafayette Square. Irish-born architect James Hoban based the neoclassical design on Leinster House in Dublin, home of the Irish legislature.

You can take this view from Pennsylvania Ave NW, or just look at the back of a $20 bill.

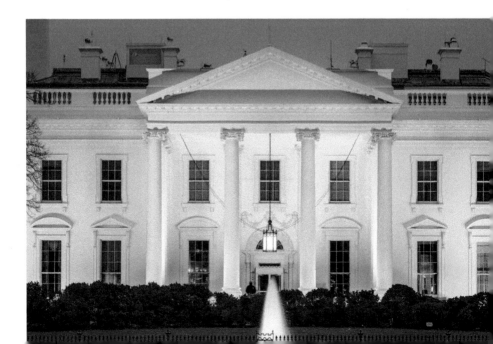

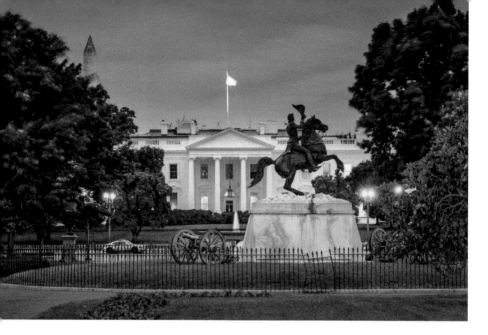

Lafayette Square

Lafayette Square is a seven-acre (30,000 m²) public park directly north of the White House, named for Marquis Gilbert de Lafayette, a French general who helped secure victory in the American Revolutionary War (1775–1783).

A statue of Lafayette stands in the southeast corner, with countryman Jean de Rochambeau (pictured) in the southwest corner. In the center stands Clark Mills' 1853 equestrian statue of President Andrew Jackson, a good foreground for the White House (above).

✉ **Addr:**	Pennsylvania Ave NW at 16th, Washington DC 20001	♀ **Where:**	38.899763 -77.036578	
❓ **What:**	Park	☾ **When:**	Anytime	
👁 **Look:**	South	Ⓦ **Wik:**	Lafayette_Square,_Washington,_D.C.	

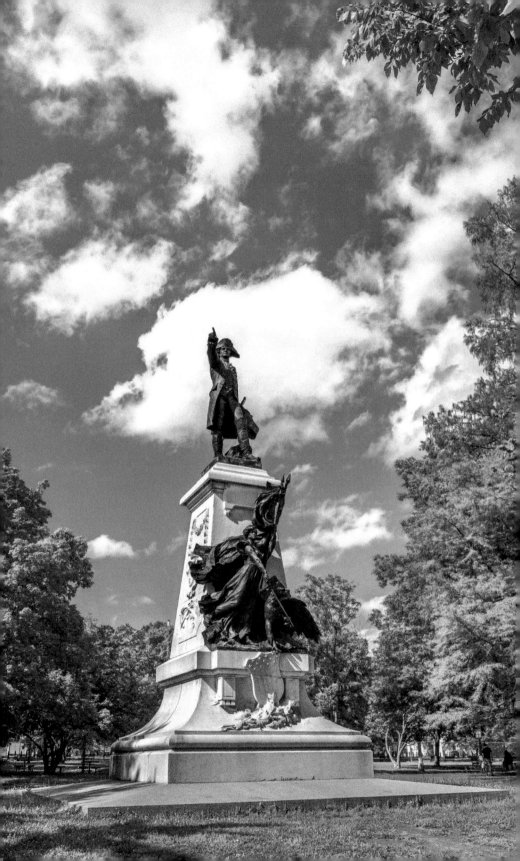

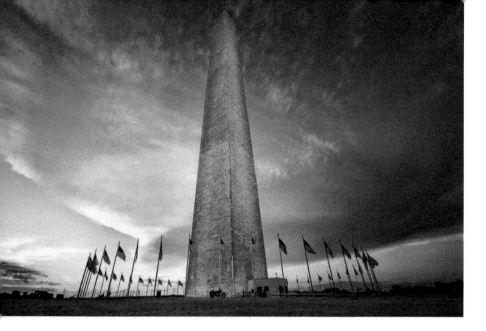

The **Washington Monument** is the world's tallest obelisk, at 555 feet (169 m).

The first 500 feet (152 m) is a hollow column with stairs and an elevator, capped with a 55-foot (17 m) pyramidion with eight observation windows and eight red aircraft warning lights, two each per side. The interior has been closed since 2016 to modernize the elevator.

The monument is surrounded by a circle of fifty American flags, and two intersecting slightly elliptical pathways.

✉ **Addr:**	Washington Monument, Washington DC 20024	♀ **Where:**	38.888409 -77.035095
☾ **When:**	Morning	👁 **Look:**	North
W **Wik:**	Washington_Monument		

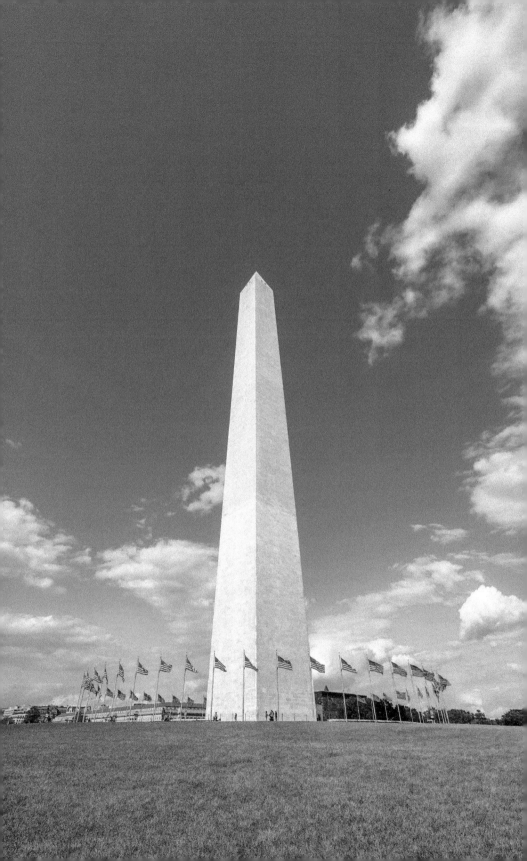

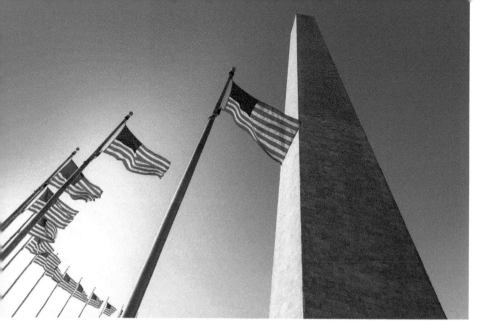

From the base of the Washington Monument, you can include a subset of the fifty flags, and see the roughly 10,000 marble blocks that finish the structure.

The proposed location, directly south of the White House and west of the Capitol, proved too unstable for such a heavy structure, so the monument's location was moved 390 feet (118.9 m) east-southeast (a small stone called the Jefferson Pier marks the original site). This forced the Lincoln Memorial to be placed about 1° south of due west of the Capitol, to align on the main axis.

✉ **Addr:**	Washington Monument, Washington DC 20024	♀ **Where:**	38.888958 -77.035221
☾ **When:**	Morning	◉ **Look:**	North
↔ **Far:**	60 m (180 feet)		

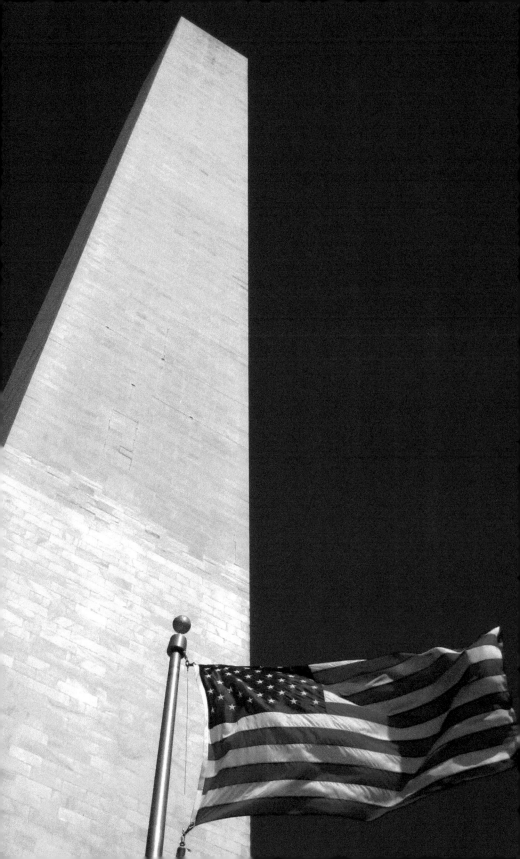

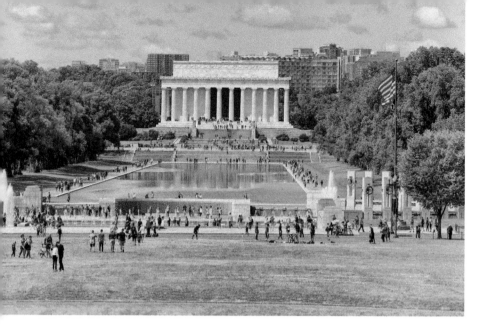

Lincoln Memorial from the Washington Monument. The slight hill on which the Washington Monument is situated provides a slightly elevated view west over the National World War II Memorial, the Lincoln Memorial Reflecting Pool, and the Lincoln Memorial. Beyond are the high-rises of Rosslyn in Arlington County, Virginia.

This view is best in the morning, with the sun in the east.

✉ **Addr:**	Washington Monument, Washington DC 20024	♀ **Where:**	38.889463 -77.035849
☼ **When:**	Morning	◉ **Look:**	West
↔ **Far:**	1.21 km (0.75 miles)		

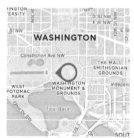

The **National Museum of African American History and Culture** is a Smithsonian Institution museum opened in 2016.

The exterior is mostly covered by an outer corona (scrim), based on railings made by enslaved 19th-century craftsmen in New Orleans and Charleston, S.C. The 3,600 panels of cast aluminum are hung at the same angle as the Washington Monument's capstone.

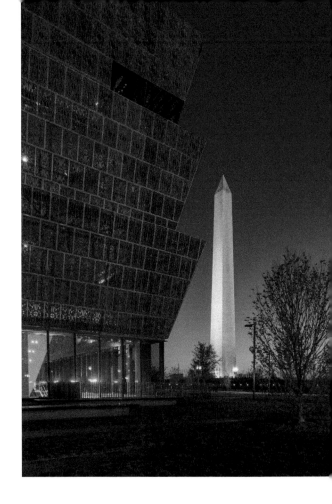

✉ **Addr:**	1400 Constitution Ave NW, Washington DC 20560	♥ **Where:**	38.891434 -77.032871
☾ **When:**	Anytime	👁 **Look:**	Southwest
↔ **Far:**	300 m (980 feet)		

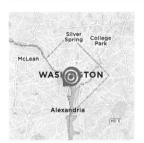
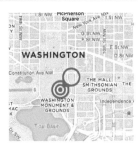

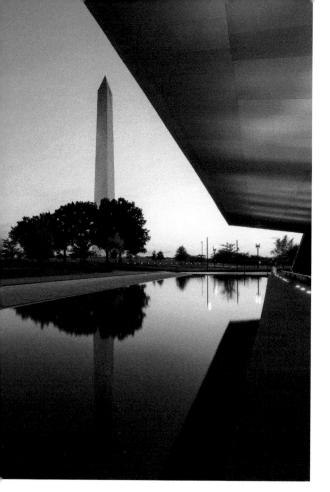

The **south elevation** of the National Museum of African American History and Culture has a small reflecting pool useful for an early morning or dusk shot.

Designed by Tanzanian-born British architect David Adjaye, the building is 60% underground, where the emotional journey includes slavery and the Underground Railroad.

✉ **Addr:**	1400 Constitution Ave NW, Washington DC 20560	♀ **Where:**	38.890507 -77.032313
When:	Anytime	👁 **Look:**	West-southwest
W **Wik:**	National_Museum_of_African_American_History_and_Culture		

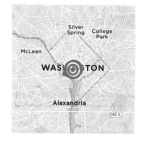

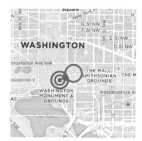

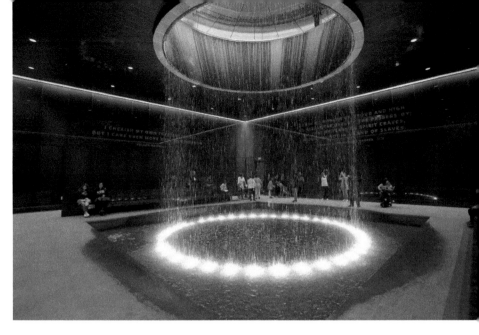

The **Contemplation Court** at the National Museum of African American History and Culture is inspired by the Martin Luther King Jr. quote "We are determined… to work and fight until justice rains down like water and righteousness like a mighty stream" (circa 1958).

From a circular skylight above, a cylindrical fountain rains down with water into a pool at the center of the room. The underground room is surrounded with subtly-lit caramel-bronze walls of Bendheim glass inscribed with select quotations.

✉ **Addr:**	NMAAHC, Washington DC 20560	♀ **Where:**	38.891485 -77.032712
❷ **What:**	Exhibit	◑ **When:**	Anytime
👁 **Look:**	North	↔ **Far:**	0 m (0 feet)

Washington Monument area > Smithsonian > National Museum of African American History and Culture > interior > Contemplation Court

51

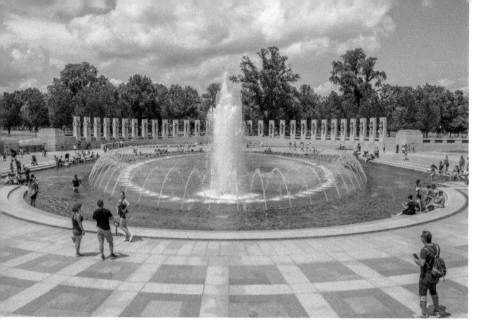

The **World War II Memorial** is located west of the Washington Monument and opened in 2004, around the pre-existing Rainbow Pool. To the north and south are two triumphal arches flanked by 56 granite pillars, representing the 48 U.S. states of 1945, as well as the District of Columbia, the Alaska Territory and Territory of Hawaii, the Commonwealth of the Philippines, Puerto Rico, Guam, American Samoa, and the U.S. Virgin Islands.

On the west side is the Freedom Wall with 4,048 gold stars, each representing 100 Americans who died in the war, with the message "Here we mark the price of freedom."

✉ **Addr:**	1750 Independence Ave SW, Washington DC 20024	♀ **Where:**	38.8889 -77.040498
❓ **What:**	Memorial	⏰ **When:**	Morning
👁 **Look:**	North	Ⓦ **Wik:**	National_World_War_II_Memorial

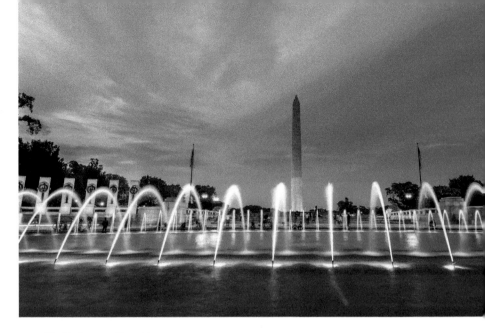

The **Rainbow Pool**, in the center of the WWII Memorial, makes a beautiful foreground for the Washington Monument (above).

Designed in 1924 by landscape architect Frederick Law Olmsted, Jr., the pool was integrated into the Memorial in 2001. There are two large fountains and 124 small nozzles in an oval-shaped bed of water 246-feet long (75 m) and 147 feet (45 m) wide. On the east side are two flagpoles flying the American flag, framing the ceremonial entrance at 17th Street.

✉ **Addr:**	WWII Memorial, Washington DC 20245	♀ **Where:**	38.889417 -77.040865	
❷ **What:**	Pool	☾ **When:**	Anytime	
👁 **Look:**	East	W **Wik:**	Rainbow_Pool	

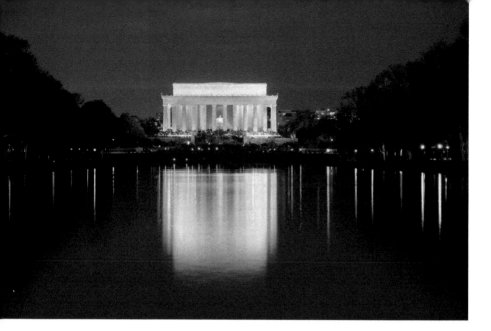

The view of the **Lincoln Memorial** from the National World War II Memorial uses the full length of the **Lincoln Memorial Reflecting Pool**.

Designed by Henry Bacon and completed in 1923, the Lincoln Memorial Reflecting Pool was is approximately 2,029 feet (618 m) long (over a third of a mile) and 167 feet (51 m) wide.

✉ **Addr:**	1750 Independence Ave SW, Washington DC 20024	♀ **Where:**	38.889397 -77.041081	
☾ **When:**	Anytime	◉ **Look:**	West	
W **Wik:**	Lincoln_Memorial_Reflecting_Pool			

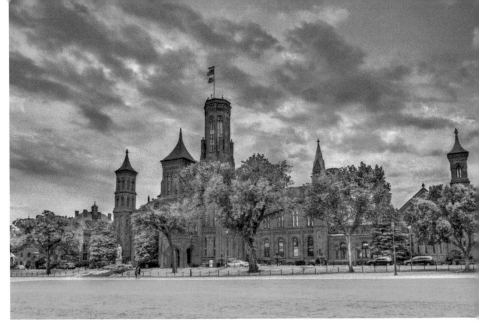

The **Smithsonian Castle** is a distinctive red structure to the south of the National Mall. The Smithsonian Institution Building is nicknamed The Castle due to its faux medieval Norman style, a 12th-century combination of late Romanesque and early Gothic motifs. Architect James Renwick, Jr chose the style to evoke the Collegiate Gothic in England and the ideas of knowledge and wisdom.

Designed in 1846 and completed in 1855, the building houses the administrative offices of the Smithsonian Institution, founded in 1835 when the estate of British scientist James Smithson passed "to the United States of America... for the increase and diffusion of knowledge". The group has nineteen museums, nine research centers, and a zoo, all free to enter.

✉ **Addr:**	1000 Jefferson Dr SW, Washington DC 20560	📍 **Where:**	38.8887472 -77.0259972	
❷ **What:**	Building	◑ **When:**	Afternoon	
👁 **Look:**	North	W **Wik:**	Smithsonian_Institution_Building	

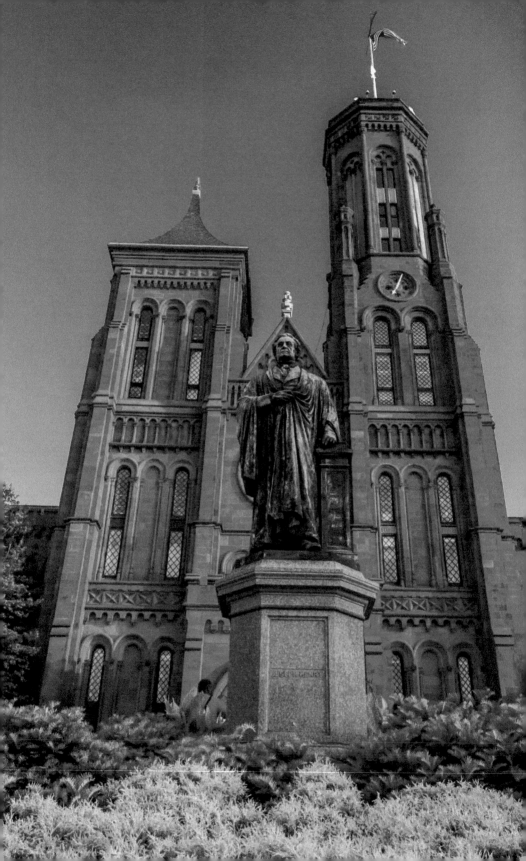

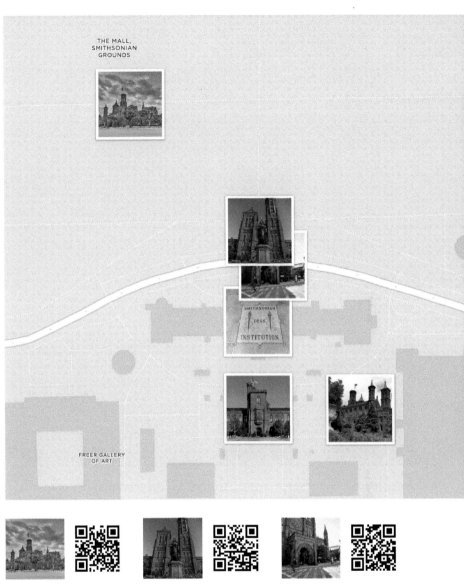

THE MALL,
SMITHSONIAN
GROUNDS

SMITHSONIAN
1846
INSTITUTION

FREER GALLERY
OF ART

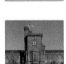

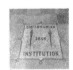

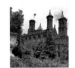

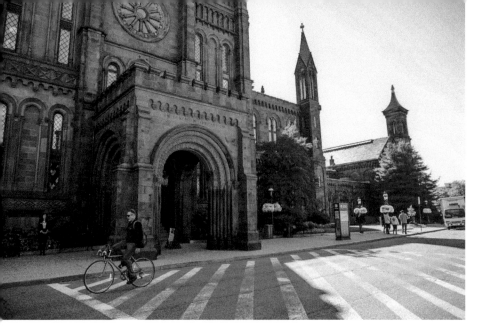

The main entrance faces north to the National Mall.

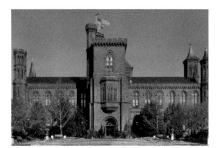
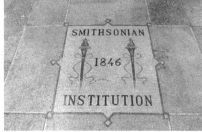

Above and below: The south facade faces a garden. Above: the marble floor.

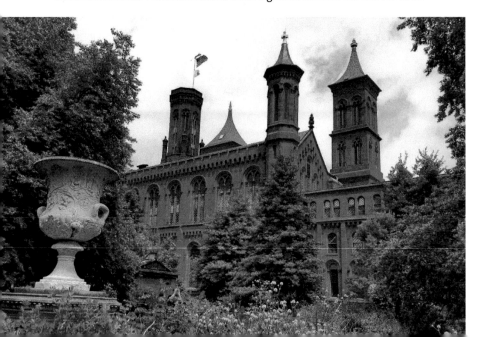

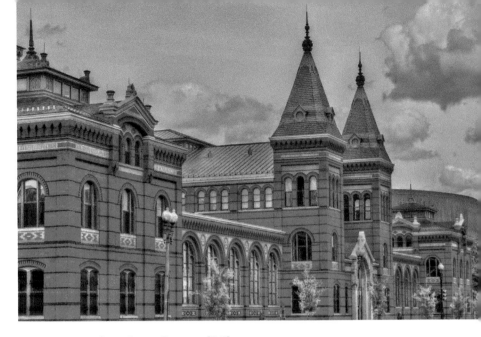

The **Arts and Industries Building** opened in 1881 as the Smithsonian's first proper exhibition space. The vibrant maroon-colored brick design was inspired by structures at the 1873 Vienna Exposition.

Over the north entrance is a sculpture entitled *Columbia Protecting Science and Industry* by sculptor Caspar Buberl. The structure is currently used for events and awaits a permanent role.

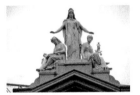

✉ **Addr:**	900 Jefferson Dr SW, Washington DC 20560	♀ **Where:**	38.88886 -77.024463
❷ **What:**	Building	◑ **When:**	Morning
◉ **Look:**	South	W **Wik:**	Arts_and_Industries_Building

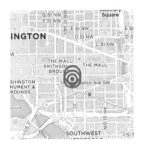

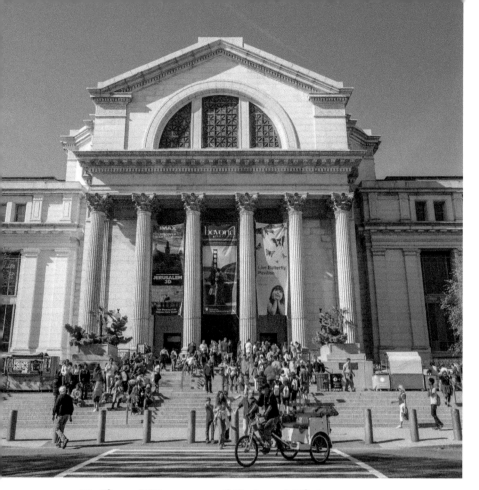

The **National Museum of Natural History** is the world's most visited natural-history museum. Opened in 1910 as the third Smithsonian building, the neoclassical-style Natural History Building sits on the north side of the National Mall.

✉ **Addr:**	10th at Constitution Ave NW, Washington DC 20560	♀ **Where:**	38.8913 -77.0259
❓ **What:**	Building	⏱ **When:**	Afternoon
👁 **Look:**	North	W **Wik:**	National_Museum_of_Natural_History

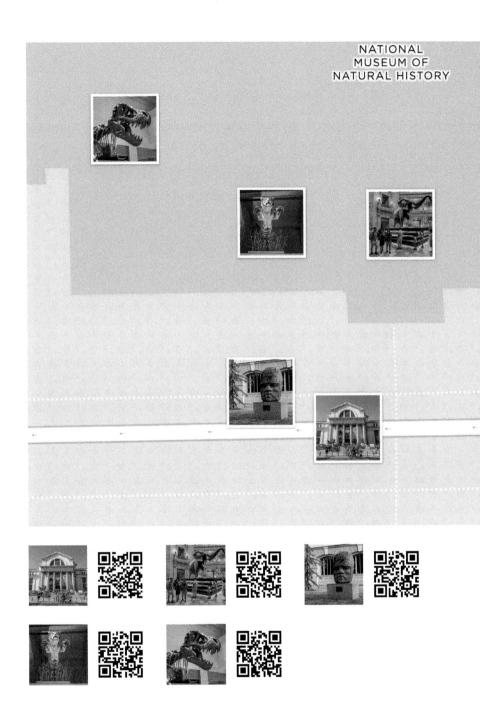

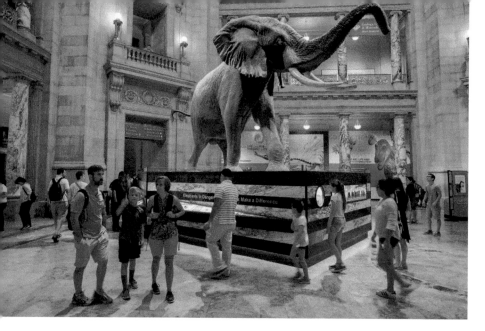

The main entrance is an octagonal rotunda.

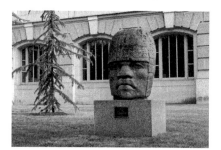

Olmec head outside; pouncing tiger; T-Rex skeleton.

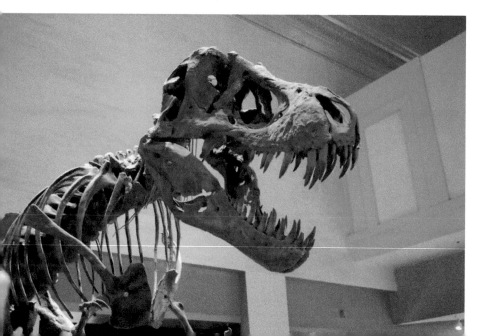

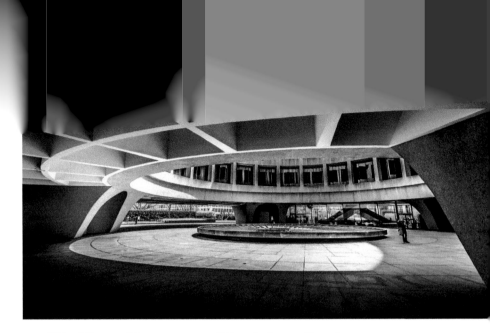

The **Hirshhorn Museum and Sculpture Garden** is a Smithsonian modern art museum, endowed in the 1960s with the permanent art collection of Joseph H. Hirshhorn. Designed by Gordon Bunshaft and opened 1974, the circular structure is elevated on four massive legs, with a large fountain in the central courtyard.

As the name suggests, there is art in and around the Hirshhorn Museum, and in the neighboring Sculpture Garden on the National Mall.

✉ **Addr:**	194 Independence Ave SW, Washington DC 20591	♥ **Where:**	38.888406 -77.022873
❷ **What:**	Museum	◑ **When:**	Morning
👁 **Look:**	South-southwest	W **Wik:**	Hirshhorn_Museum_and_Sculpture_Garden

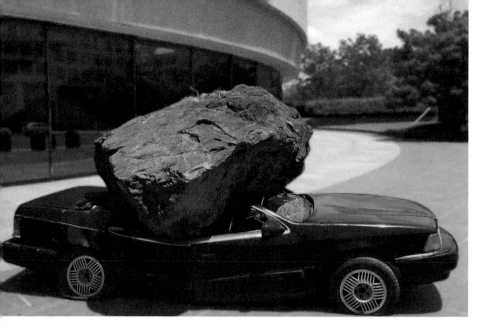

Above: Do not park here, the fine can be crushing. Perhaps as a warning to others, the Hirshhorn features this 2007 sculpture by Jimmie Durham titled *Still Life with Spirit and Xitle.*

Below: At the entrance to the sculpture garden is Jeff Koons' 1987 replica of a German statue of a travelling merchant, *Kiepenkerl.*

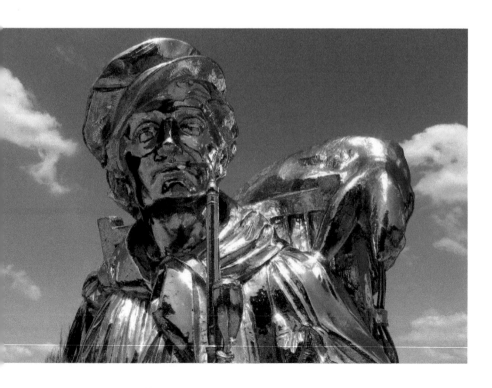

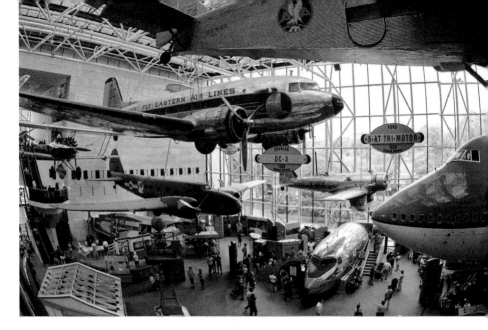

The **National Air and Space Museum** (NASM) is the country's most visited museum. Of note are the Wright brothers' plane, Charles Lindbergh's Spirit of St. Louis, the Bell X-1 which broke the sound barrier, and the Apollo 11 command module.

Established in 1946, the museum opened this main facility on the National Mall in 1976. Designed by St. Louis-based architect Gyo Obata of HOK, the building is four simple marble-encased cubes connected by three spacious steel-and-glass atria which house the larger exhibits. An annex opened in 2003 at Dulles International Airport.

✉ **Addr:**	600 Independence Ave SW, Washington DC 20560	♥ **Where:**	38.888 -77.020	
❷ **What:**	Museum	◕ **When:**	Afternoon	
👁 **Look:**	North	W **Wik:**	National_Air_and_Space_Museum	

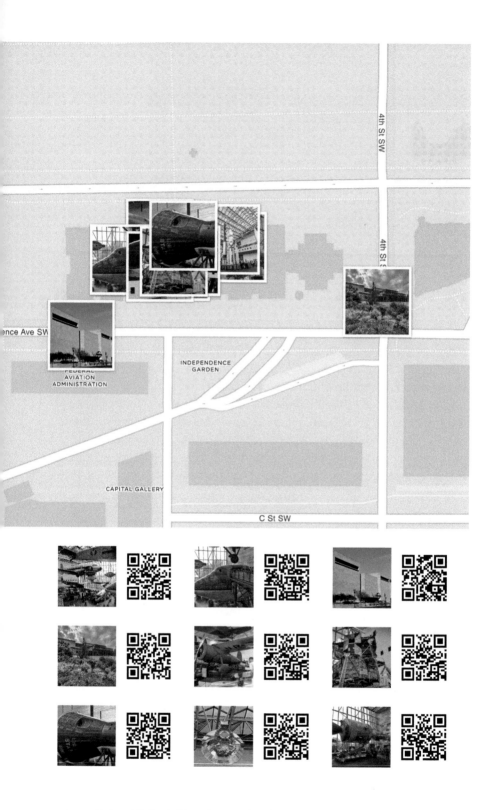

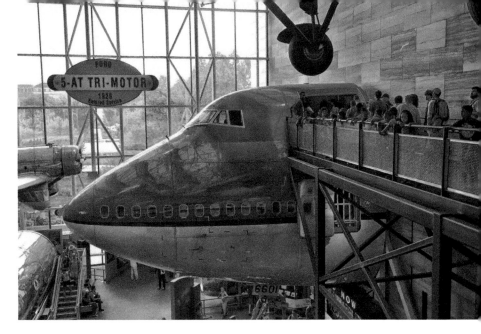

Step inside the cockpit of a Boeing 747-100B in America by Air.

Exterior north and east; Amelia Earhart's Lockheed Vega in Pioneers of Flight.

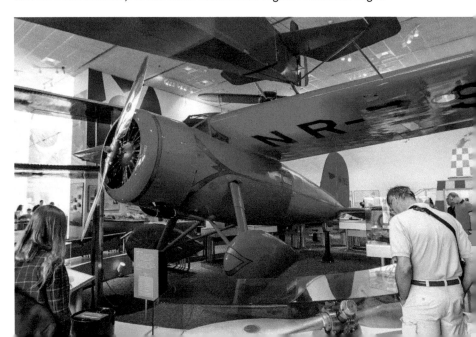

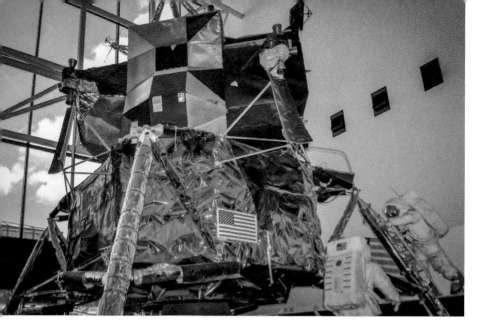

Apollo Lunar Module LM-2 in Milestones of Flight.

Gemini IV capsule; Pioneer H; Apollo-Soyuz in Space Race.

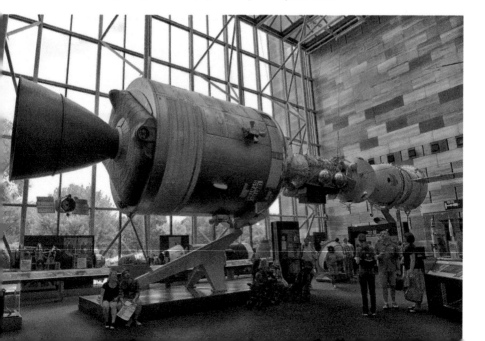

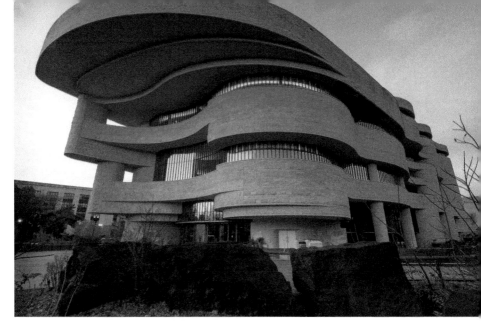

The **National Museum of the American Indian** opened in 2004 as the country's first national museum dedicated exclusively to Native Americans. The five-story, curvilinear building is clad in a golden-colored Kasota limestone designed to evoke natural rock formations shaped by wind and water over thousands of years.

This view is from the NE corner, by a statue called *Buffalo Dancer II*. Inside is the 120-foot-high Potomac Atrium.

✉ **Addr:**	482 Independence Ave SW, Washington DC 20024	♀ **Where:**	38.888585 -77.015956
❷ **What:**	Museum	☾ **When:**	Morning
👁 **Look:**	Southwest	W **Wik:**	National_Museum_of_the_American_Indian#National_Mall_(Washington_D.C.)

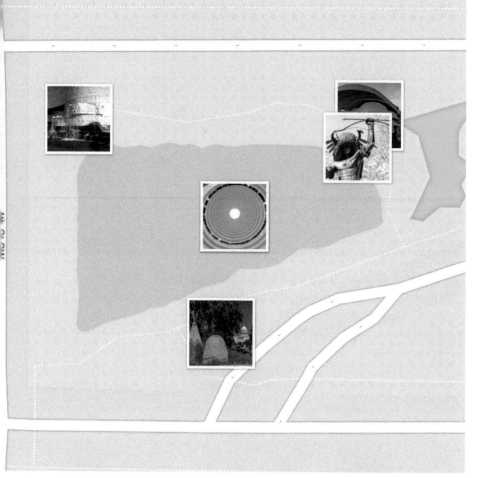

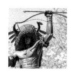

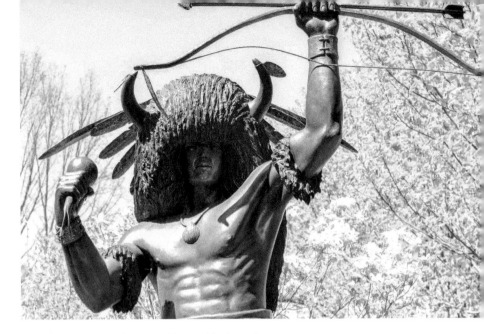

Buffalo Dancer II has been working on his six pack.

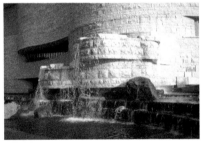

Always Becoming, waterfall, atrium ceiling.

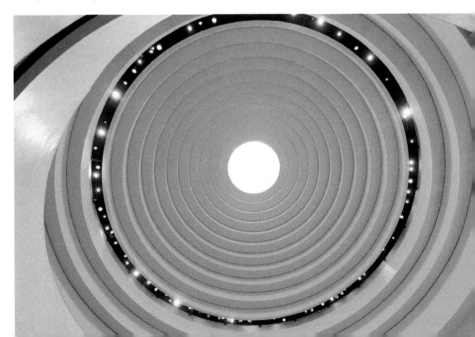

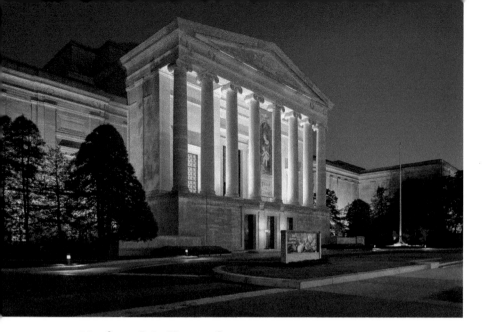

The **National Gallery of Art** is a private-public museum on the northeast side of the National Mall. Not part of the Smithsonian, the Gallery was established in 1937 by banker Andrew W. Mellon and donated to the country.

There are three sections. In the center, what is now called the West Building was designed by John Russell, architect of the Jefferson Memorial. Completed in 1941, the building is made of pink Tennessee marble, with a domed rotunda modeled on the Pantheon in Rome.

To the east is the, well, East Building, designed by I. M. Pei with a vast triangular atrium and opened in 1978. The two are connected by an underground walkway called "the Concourse", lined for 200 feet (61 m) by an LED light sculpture by Leo Villareal called *Multiverse*.

On the east side is a sculpture garden, opened in 1999.

✉ **Addr:**	Constitution Ave NW, Washington DC 20565	♀ **Where:**	38.891273 -77.019978
❓ **What:**	Museum	◑ **When:**	Afternoon
👁 **Look:**	North	W **Wik:**	National_Gallery_of_Art

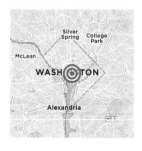
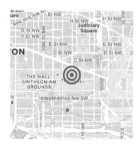
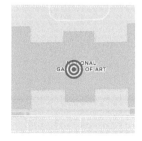

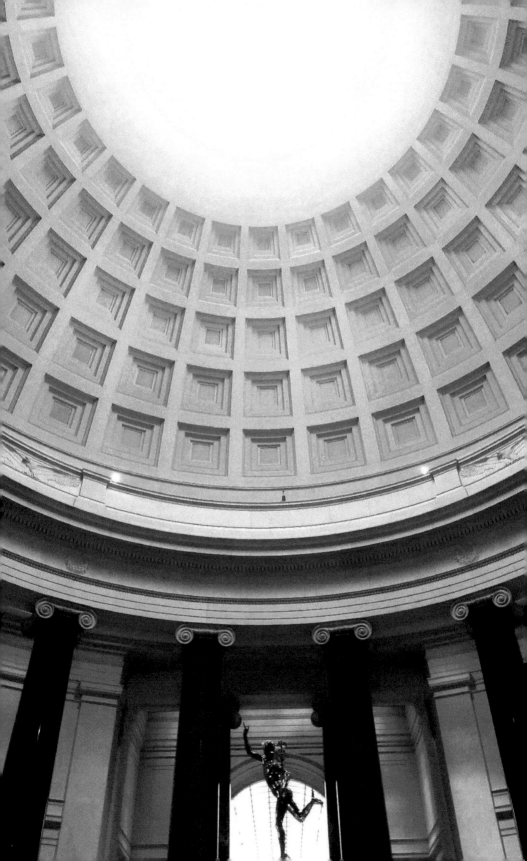

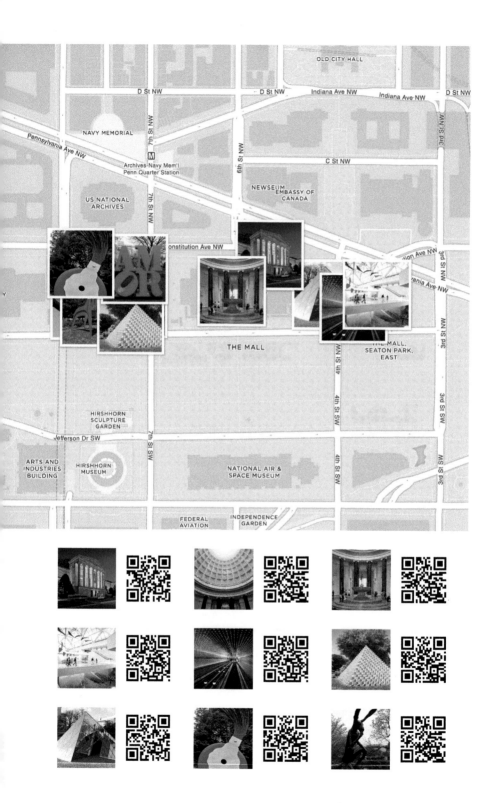

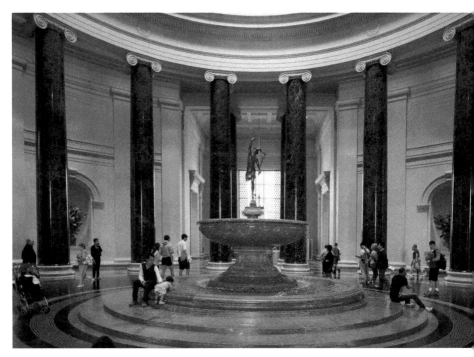

Above: Rotunda of the original (west) building. Below: Atrium of the new (east) building. Right: *Multiverse* LED artwork along the tunnel between the two buildings.

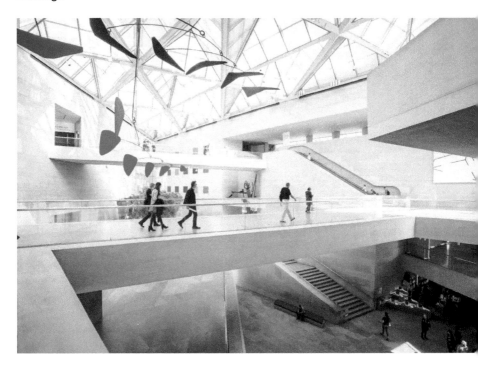

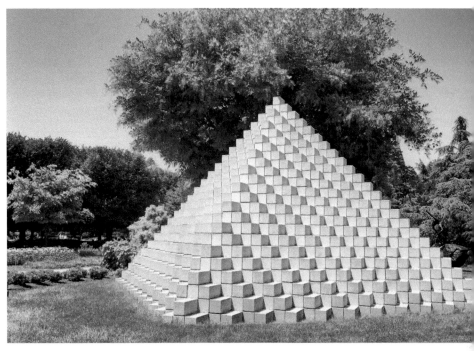

Above: *Four-Sided Pyramid* by Sol LeWitt in the Sculpture Garden.
Below: Glass tetrahedrons and a cascading waterfall in the plaza between the West and East buildings.

The six-acre Sculpture Garden to the west of the West Building includes, clockwise from top left: *Typewriter Eraser* (1998, cast 1999) by Claes Oldenburg and Coosje van Bruggen; *Thinker on a Rock* (1997) by Barry Flanagan, based on Rodin's Thinker (1880); *AMOR* (conceived 1998, executed 2006) by Robert Indiana, based on his "LOVE" graphic; *Cheval Rouge* (Red Horse), 1974, by Alexander Calder.

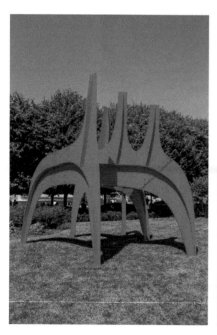
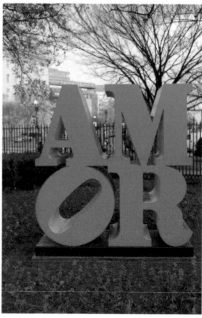

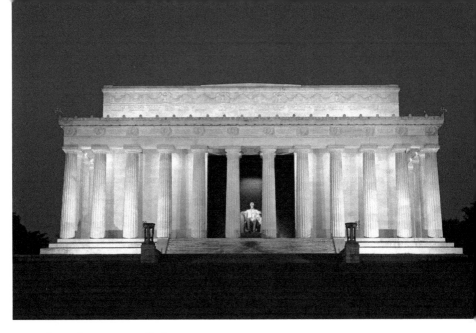

The **Lincoln Memorial** on the far west side of the National Mall area honors the 16th President of the United States, Abraham Lincoln. Dedicated in May 1922, the Greek Doric temple by Henry Bacon is surrounded by a peristyle of 36 fluted Doric columns, one for each of the 36 states in the Union at the time of Lincoln's death.

In front, and also designed by Bacon, is the Lincoln Memorial Reflecting Pool, the largest of the many reflecting pools in Washington, D.C., stretching 2,029 feet (618 m) — over a third of a mile.

✉ **Addr:**	Lincoln Memorial, Washington DC 20037	♀ **Where:**	38.889246 -77.050123
❓ What:	Exterior	**☼ When:**	Afternoon
👁 Look:	North	**W Wik:**	Lincoln_Memorial

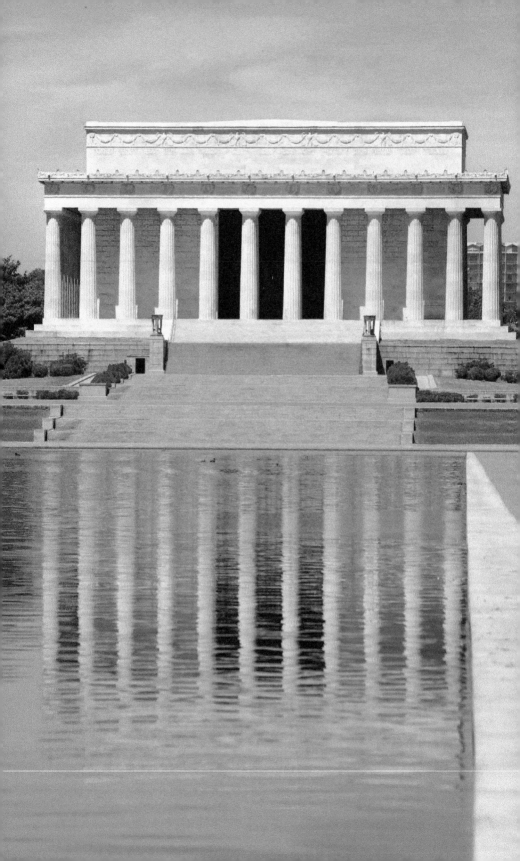

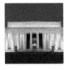

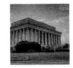
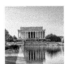

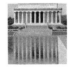

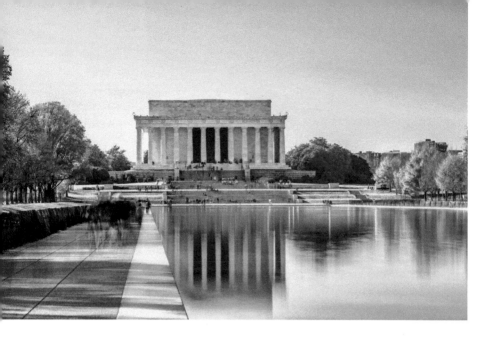

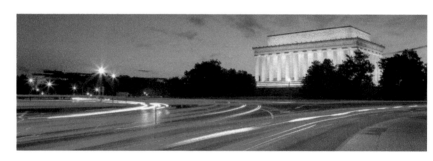

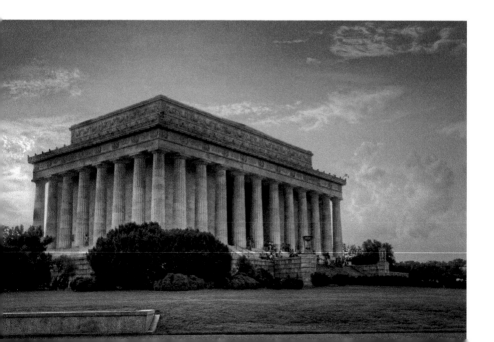

The Lincoln Memorial has become a symbolically sacred venue especially for the Civil Rights Movement. In 1939, the Daughters of the American Revolution refused to allow the African-American contralto Marian Anderson to perform before an integrated audience. Instead, with the support of Eleanor Roosevelt, she sang on the steps of the Lincoln Memorial, to a live audience of 75,000, and a nationwide radio audience.

During the March on Washington for Jobs and Freedom in 1969, Martin Luther King Jr., delivered his historic "I Have a Dream" speech. An inscription at the top of the steps marks where King stood.

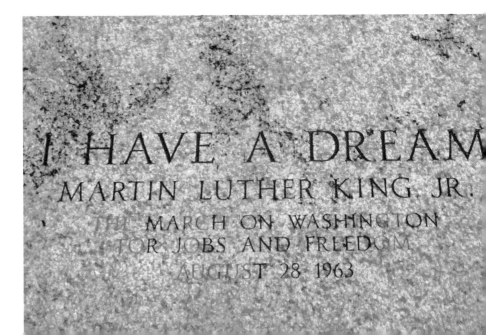

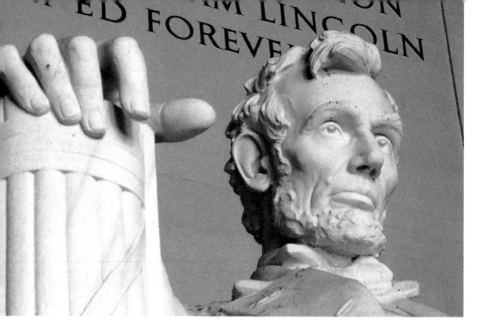

Abraham Lincoln is a giant sculpture of the namesake President, sitting in contemplation. Designed by sculptor, Daniel Chester French, the statue was carved from Georgia white marble by the Piccirilli Brothers.

Towering 19 feet (5.8 m) high from head to foot, the scale is such that if Lincoln were standing, he would be 28 feet (8.5 m) tall. The widest span of the statue corresponds to its height, so that the statue is essentially a cube.

✉ **Addr:**	Lincoln Memorial, Washington DC 20037	♀ **Where:**	38.889276 -77.050203
❓ What:	Statue	**◔ When:**	Afternoon
👁 Look:	North	**W Wik:**	Abraham_Lincoln_(1920_statue)

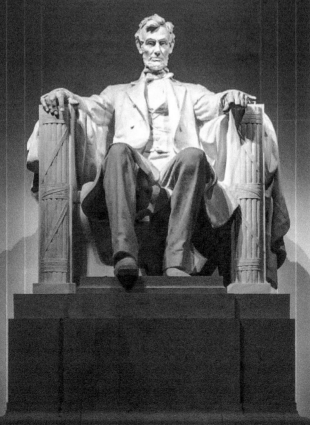
IN THIS TEMPLE
AS IN THE HEARTS OF THE PEOPLE
FOR WHOM HE SAVED THE UNION
THE MEMORY OF ABRAHAM LINCOLN
IS ENSHRINED FOREVER

LINC
MEMO

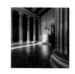
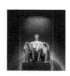

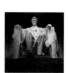

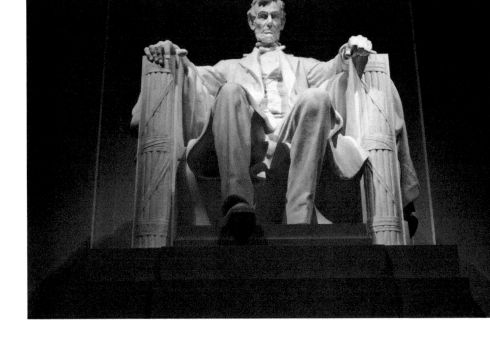

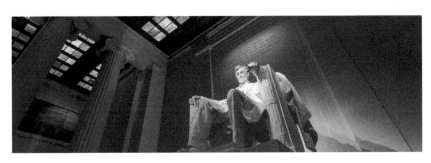

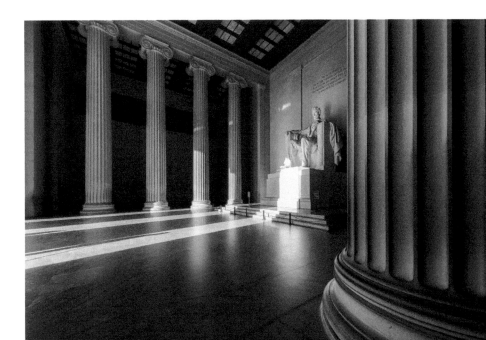

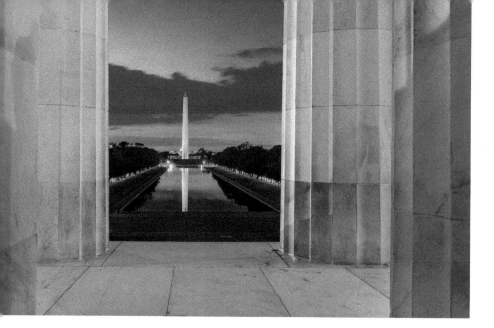

The view of **Washington Monument from Lincoln Memorial** is framed by two rows of Doric columns and enhanced by the Lincoln Memorial Reflecting Pool.

✉ **Addr:**	Lincoln Memorial, Washington DC 20037	♀ **Where:**	38.889221 -77.050016
❓ **What:**	Views	⏲ **When:**	Afternoon
👁 **Look:**	North	↔ **Far:**	0 m (0 feet)

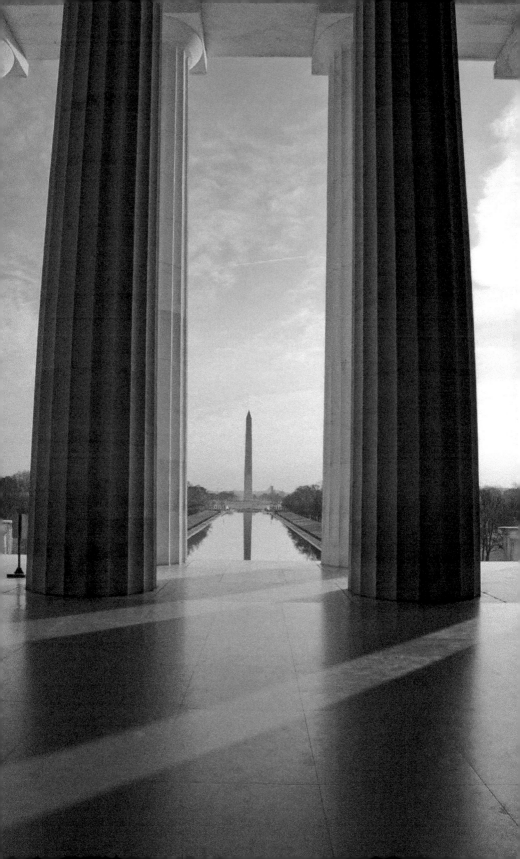

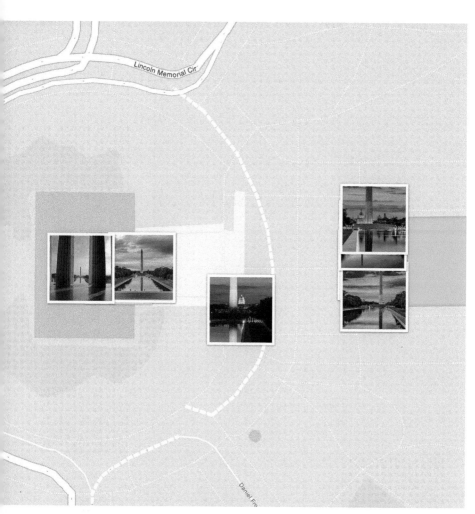

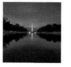

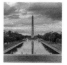

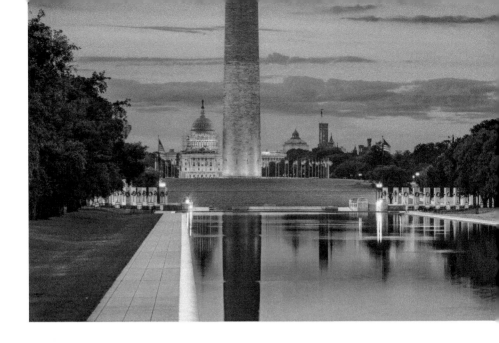

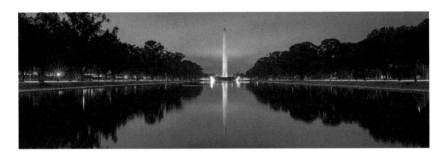

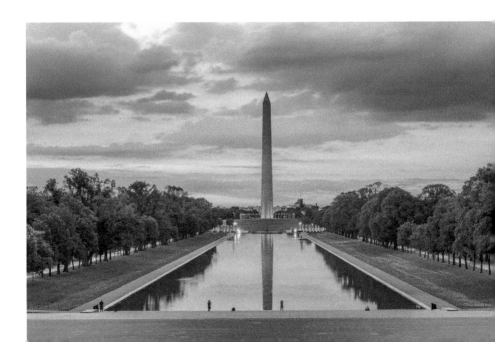

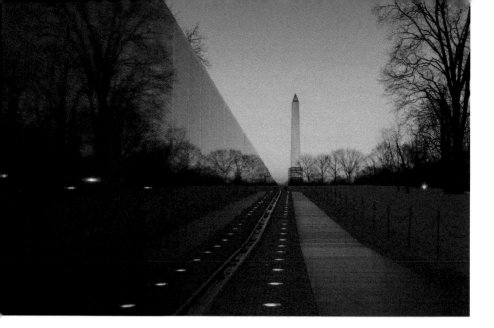

The **Vietnam Veterans Memorial Wall**, northeast of the Lincoln Memorial, consists of two black granite walls etched with the names of over 58,000 U.S. lost service members. Polished like a mirror, when a visitor looks upon the wall, his or her reflection can be seen simultaneously with the engraved names, symbolically bringing the past and present together.

✉ Addr:	5 Henry Bacon Dr NW, Washington DC 20245	♀ Where:	38.8912506 -77.0476837
❓ What:	Memorial	⏱ When:	Anytime
👁 Look:	East	Ⓦ Wik:	Vietnam_Veterans_Memorial#Memorial_Wall

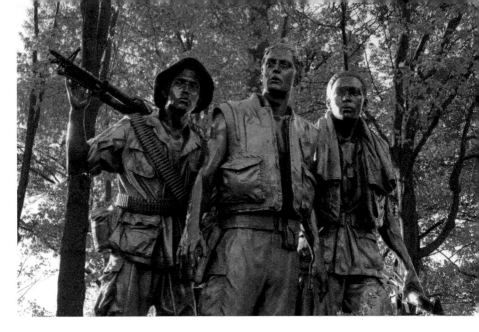

The Three Soldiers is a bronze statue group about 150 feet from the Vietnam Veterans Memorial Wall, upon which they gaze as though "looking over a sea of the fallen."

Unveiled in 1984 and officially titled the "Three Servicemen", the seven-foot-tall heroic-sized men were based on real people and were the first representation of an African American and a Hispanic American on the National Mall.

The statue is the second part of the Vietnam Veterans Memorial.

✉ **Addr:**	274 Henry Bacon Dr NW, Washington DC 20245	♀ **Where:**	38.8905732 -77.0482112
❷ **What:**	Statue	◑ **When:**	Afternoon
👁 **Look:**	Southeast	W **Wik:**	The_Three_Soldiers

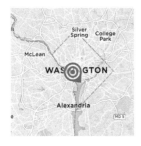

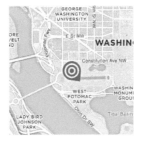

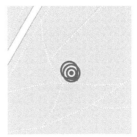

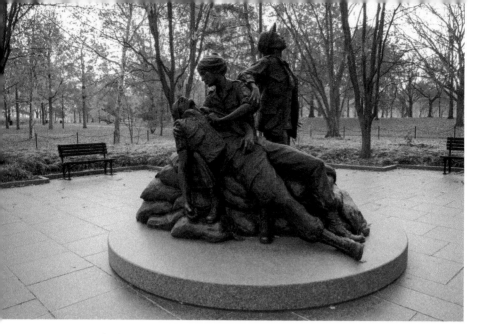

The **Vietnam Women's Memorial** is the third part of the Vietnam Veterans Memorial, located a short distance south of the Wall. Dedicated to U.S. women who served in the Vietnam War, most of whom were nurses, the memorial depicts three uniformed women with a wounded soldier.

Diane Carlson Evans, RN, a former Army nurse, founded the Vietnam Women's Memorial Project (now the Vietnam Women's Memorial Foundation) in 1984. The monument was designed by Glenna Goodacre and dedicated in 1993.

✉ **Addr:**	west Potomac Park, Washington DC 20245	♀ **Where:**	38.8904 -77.0469
❓ **What:**	Memorial	◑ **When:**	Afternoon
👁 **Look:**	North	W **Wik:**	Vietnam_Women%27s_Memorial

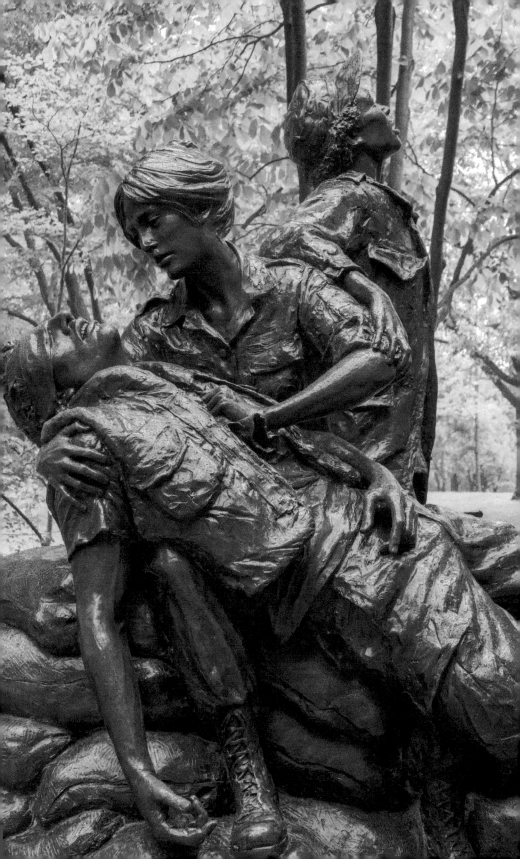

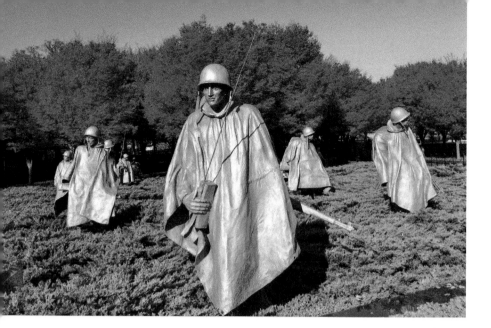

The **Korean War Veterans Memorial** is located southeast of the Lincoln Memorial. Dedicated in 1995, the memorial consists of several walls, a pool, and nineteen statues.

The seven-foot-tall statues, designed by Frank Gaylord, depict a platoon on patrol, dressed in full combat gear. They are enclosed by a triangular Mural Wall with over 2,500 archival photos sandblasted into the black granite.

Nearby is the United Nations Wall, listing the 22 countries that contributed troops or medical support to the Korean War effort.

✉ **Addr:**	10 Daniel French Dr SW, Washington DC 20245	♀ **Where:**	38.887708 -77.047512
❓ **What:**	Memorial	🕐 **When:**	Morning
👁 **Look:**	North-northwest	W **Wik:**	Korean_War_Veterans_Memorial

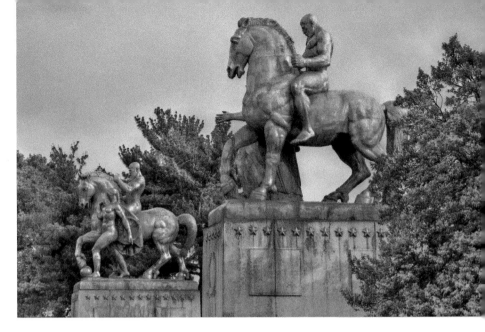

The Arts of War and **The Arts of Peace** are two pairs of bronze, fire-gilded statues, located west of the Lincoln Memorial. Installed in 1951, the two groups are in different styles and by different sculptors.

At the entrance to Arlington Memorial Bridge are *The Arts of War* (above) by Leo Friedlander with *Valor* (south) and *Sacrifice* (north) in an Art Deco style.

North by 600 feet (180 m) at Rock Creek Pkwy are *The Art of Peace* (right) by James Earle Fraser, with *Aspiration and Literature* (south) and *Music and Harvest* (north) in a neoclassical style.

✉ **Addr:**	Arlington Memorial Bridge, Washington DC 20037	♀ **Where:**	38.8891333 -77.0522595	
❓ **What:**	Sculpture	◑ **When:**	Afternoon	
👁 **Look:**	South-southeast	W **Wik:**	The_Arts_of_War_and_The_Arts_of_Peace	

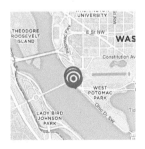

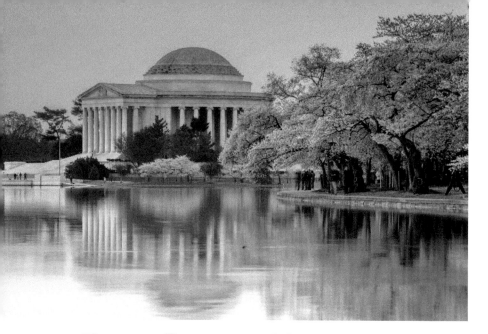

The **Thomas Jefferson Memorial** honors the main drafter and writer of the Declaration of Independence. The neoclassical building by John Russell Pope was completed in 1943 and a bronze statue of Jefferson by Rudulph Evans was added in 1947.

Located due south of the White House, the Memorial lies on the shore of the Tidal Basin, which affords many reflective views. The almost circular shoreline comes to life in March and April with blossoming Japanese cherry trees.

✉ **Addr:**	900 Ohio Dr SW, Washington DC 20024	♀ **Where:**	38.885159 -77.044576
❷ **What:**	Presidential memorial	☽ **When:**	Afternoon
👁 **Look:**	East-southeast	W **Wik:**	Jefferson_Memorial

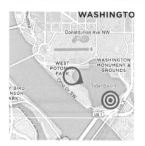

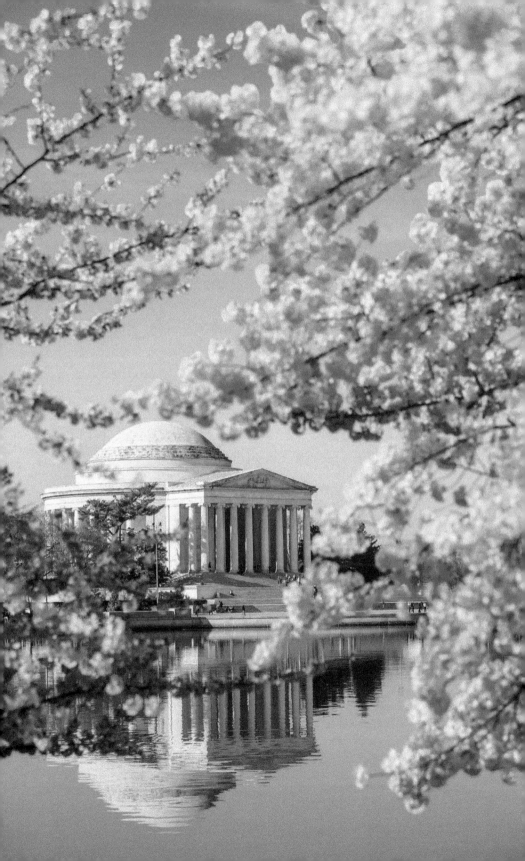

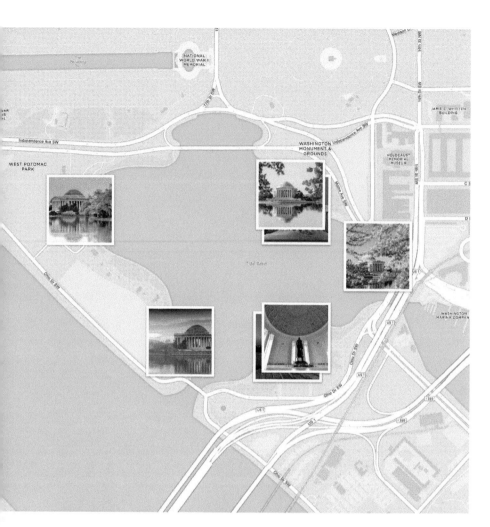

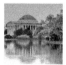

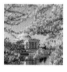

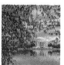
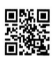
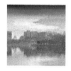
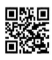

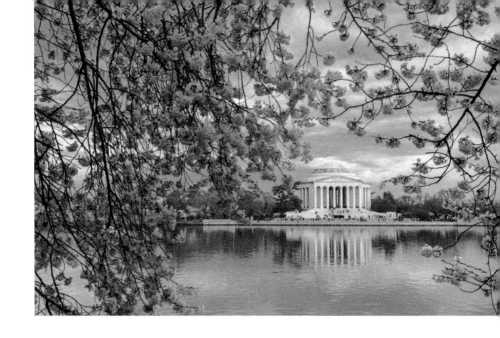

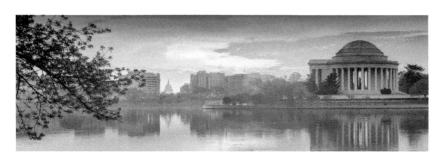

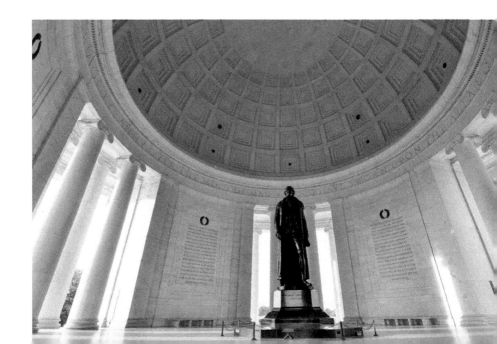

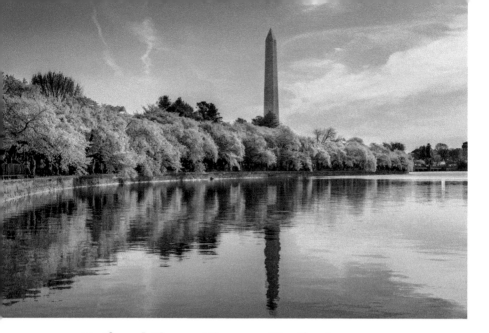

The **National Cherry Blossom Festival** is a veritable photographer's dream, a three-week long celebration from late March to mid-April.

Over 3,000 Japanese cherry trees encircle the Tidal Basin and the Washington Monument, painting the nation's capital with a ribbon of pink and white. Peak bloom is around April 4 but varies year-to-year, with the National Park Service saying "forecasting peak bloom is almost impossible more than 10 days in advance."

In 1885, Eliza Ruhamah Scidmore returned from her first trip to Japan and proposed planting cherry trees along the reclaimed waterfront of the Potomac River. Her efforts inspired botanist David Fairchild and his fiance Marian, the daughter of inventor Alexander Graham Bell, to import and plant 1,000 cherry trees from Japan in 1906, and the Japanese chemist who discovered adrenaline, Jokichi Takamine, to donate 3,020 cherry trees in 1912.

You can use the trees to frame romantic views of the Jefferson Memorial and Washington Monument. There are two stone structures that you can use for foregrounds — a 300-year-old stone lantern and a stone pagoda, both donated (in 1954and 1957) by Japan to commemorate the signing of the 1854 Japan-US Treaty of Amity and Friendship.

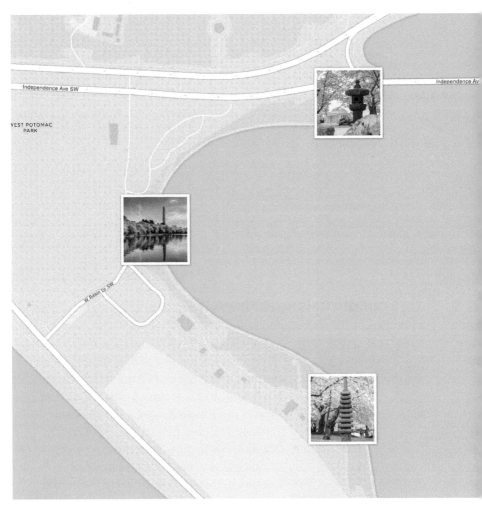

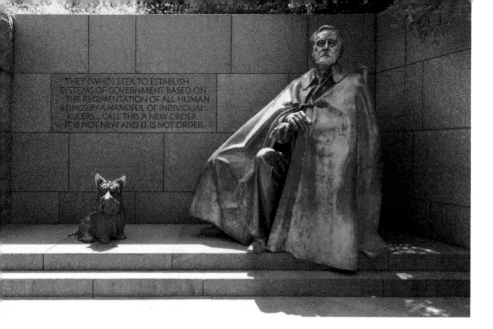

The **Franklin Delano Roosevelt Memorial** honors the 32nd President of the United States, and the era he represents.

Dedicated in 1997, the monument, traces 12 years of the history of the United States through a sequence of four outdoor rooms, one for each of FDR's terms of office. One room depicts the wheelchair-seated president alongside his dog Fala, a Scottish Terrier. Others show people listening to a radio; standing in a bread line; and Eleanor Roosevelt, the only presidential memorial depiction of a First Lady.

Each "room" contains a successively larger waterfall, reflecting the increasing complexity of a presidency marked by the vast upheavals of economic depression and world war.

✉ **Adds:**	1850 West Basin Dr SW Washington DC 20242	♀ **Where:**	38.882836 -77.042294
❓ **What:**	Memorial	🕐 **When:**	Afternoon
👁 **Look:**	South-southeast	W **Wik:**	Franklin_Delano_Roosevelt_Memorial

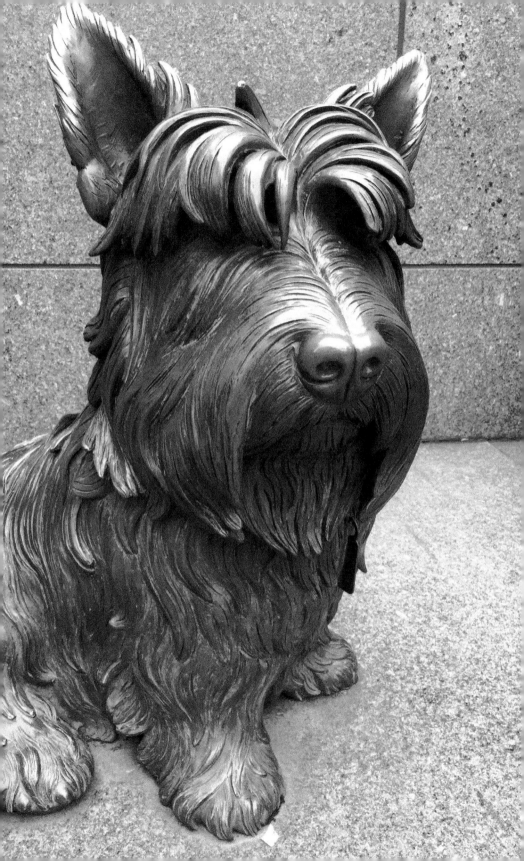

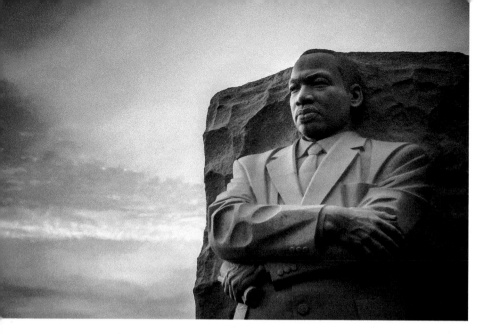

The **Martin Luther King Jr. Memorial** covers four acres along the Tidal Basin, along a sightline between the Lincoln Memorial and the Jefferson Memorial.

In the center is the **Stone of Hope**, a 30 foot high (9.1 m) granite relief of the Civil Rights Movement leader carved by Lei Yixin, inspired by a line from King's "I Have A Dream" speech: "Out of the mountain of despair, a stone of hope." The rock appears to have separated out from a rock wall behind — the "mountain of despair" — where visitors enter.

Opened in 2011, the Memorial also includes a 450 feet (140 m)-long crescent-shaped inscription wall includes excerpts from many of King's sermons and speeches.

✉ **Addr:**	Martin Luther King Memorial, Washington DC 20245	♥ **Where:**	38.886094 -77.044127
❓ **What:**	Sculpture	◑ **When:**	Sunrise
👁 **Look:**	East-northeast	↔ **Far:**	2 m (7 feet)

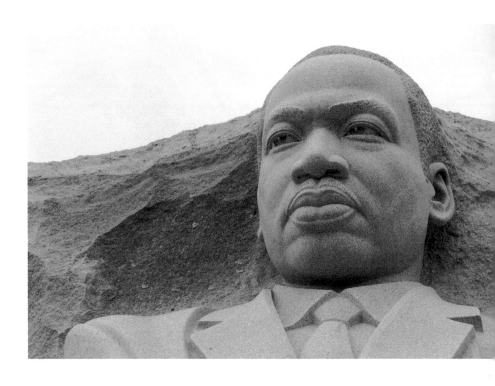

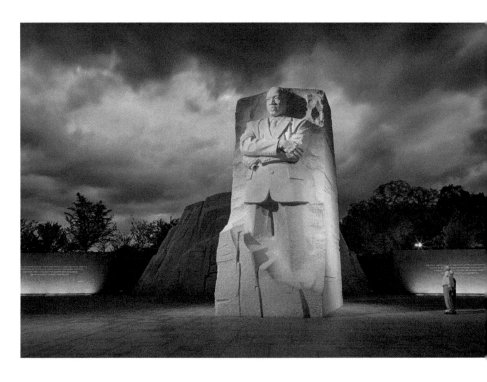

Jefferson Memorial area > Martin Luther King Jr Memorial > Stone of Hope 107

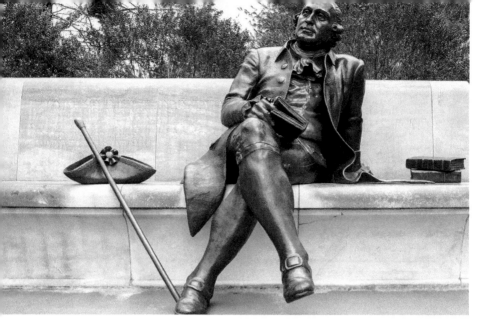

The **George Mason Memorial** remembers the Founding Father author of the Virginia Declaration of Rights who created much of the language, inspiration, and groundwork for what became the United States Bill of Rights. Mason, an Anti-Federalist, did not sign the United States Constitution because it did not abolish the slave trade and because he did not think it had necessary protection for the individual from the federal government.

Dedicated in 2002, the memorial includes a sculpture of Mason by Wendy Ross, a pool, a trellis, circular hedges, and numerous inscriptions. Mason has three books, *De Officiis* by Cicero, *On Understanding* by John Locke and *Du Contract Social* by Jean-Jacques Rousseau.

✉ **Addr:**	900 Ohio Dr SW, Washington DC 20024	♀ **Where:**	38.879538 -77.039129	
❓ **What:**	Memorial	◑ **When:**	Afternoon	
👁 **Look:**	East-southeast	W **Wik:**	George_Mason_Memorial	

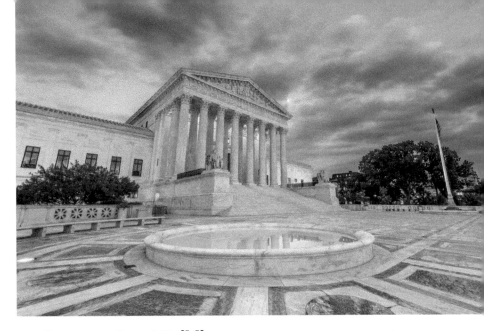

The **Supreme Court Building** houses the Supreme Court of the United States. Designed by Cass Gilbert and completed in 1935, the building is immediately east of the United States Capitol.

The Front Plaza (facing the Capitol) has two round reflecting pools and two seated figures: *The Authority of Law* (south side) and *The Contemplation of Justice* (north side), both by James Earle Fraser. The famous steps lead to a portico of tall Corinthian columns. Above, the pediment declares "Equal Justice Under Law", a phrase dating back to ancient Greece.

Inside, the courtroom is on the second floor, and there are two self-supporting marble spiral staircases.

✉ **Addr:**	1 First St NE, Washington DC 20543	⚲ **Where:**	38.890561 -77.006049
❓ What:	Building	**◐ When:**	Afternoon
👁 Look:	East	W **Wik:**	United_States_Supreme_Court_Building

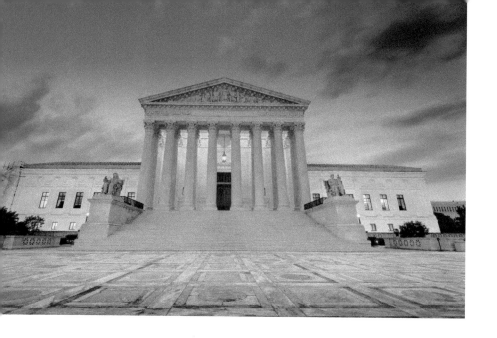

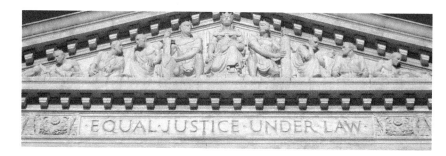

EQUAL·JUSTICE·UNDER·LAW

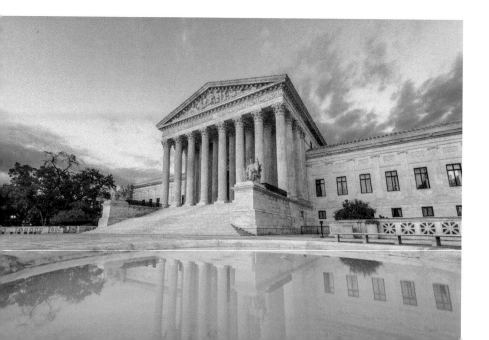

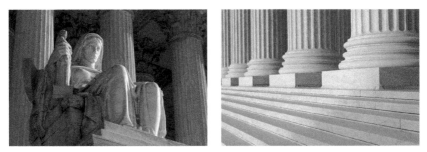

The Courtroom with seats for the nine justices can be viewed by the public.

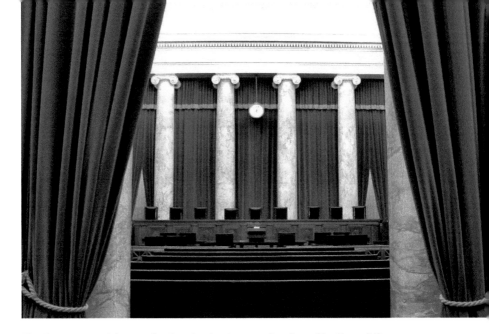

The *Contemplation of Justice* statue; One of the two marble spiral staircases.

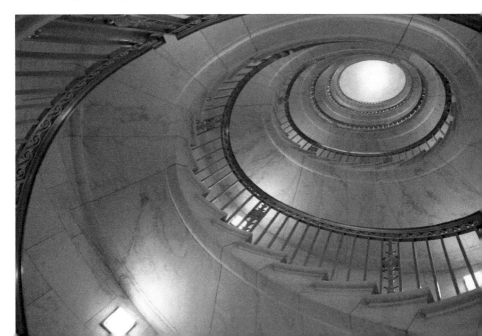

The **Library of Congress** (LOC) is the *de facto* national library of the United States. Established in 1800, it is the country's oldest federal cultural institution and the largest library in the world.

The oldest of its four buildings is the Thomas Jefferson Building (pictured), built between 1890 and 1897.

The Beaux-Arts style building by Paul J. Pelz and Edward Pearce Casey is known for its classicizing facade and elaborately decorated interior, one of the richest public interiors in the United States. Highlights are the Main Hall and Main Reading Room.

✉ **Addr:**	100 First St SE, Washington DC 20543	📍 **Where:**	38.8887 -77.0046
❓ **What:**	Building	🕐 **When:**	Afternoon
👁 **Look:**	North	W **Wik:**	Thomas_Jefferson_Building

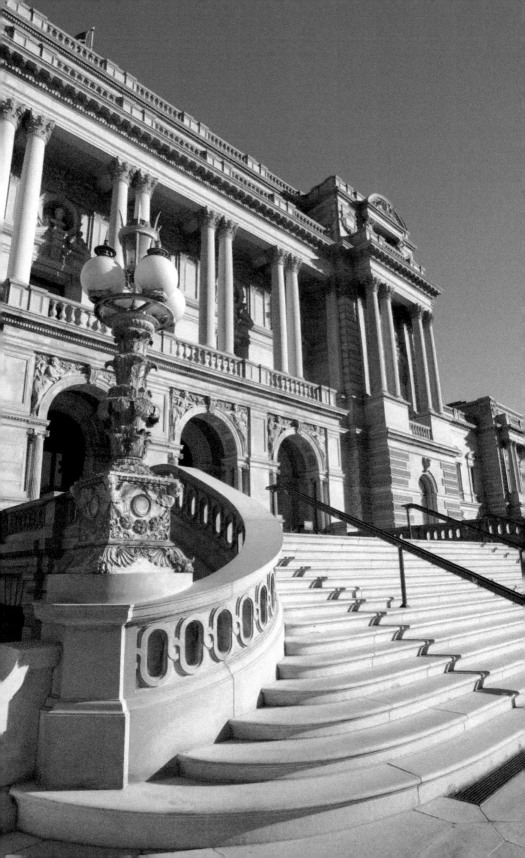

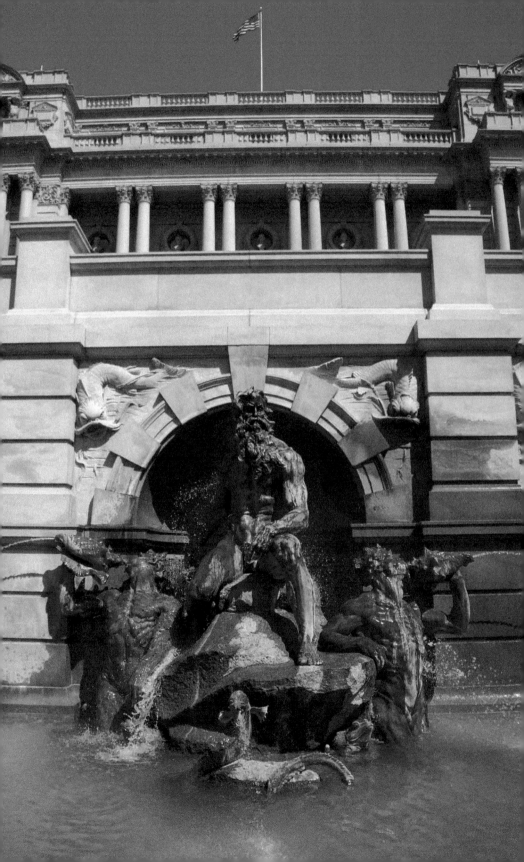

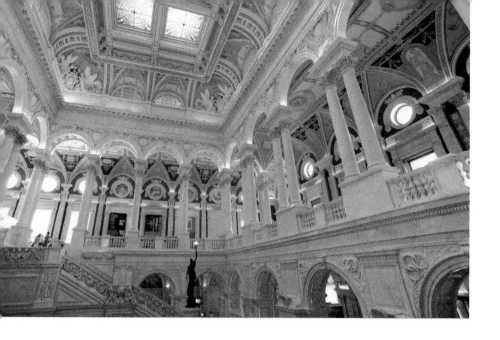

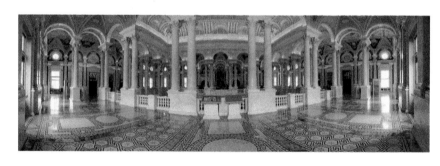

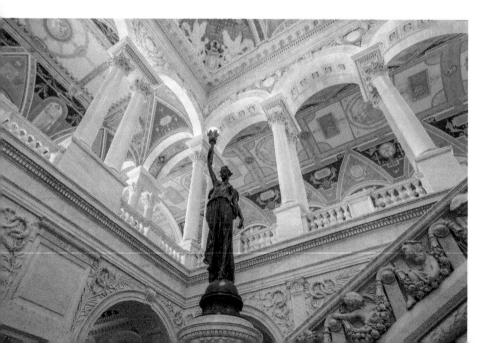

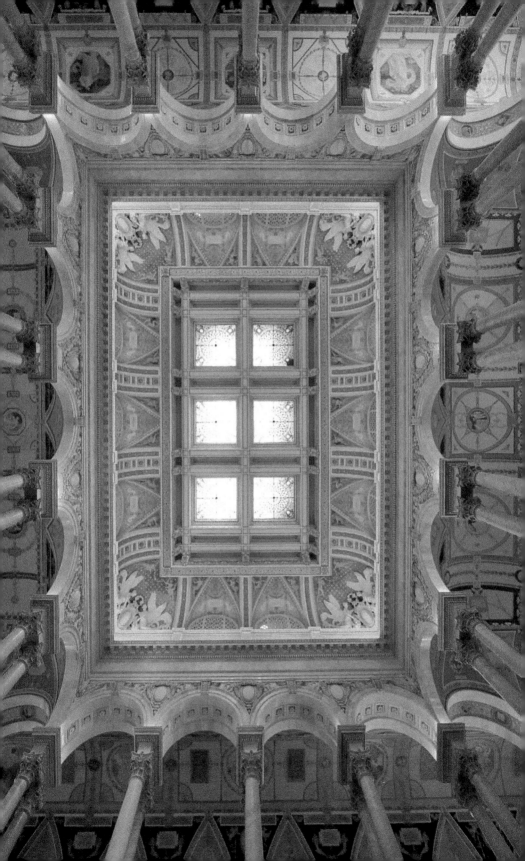

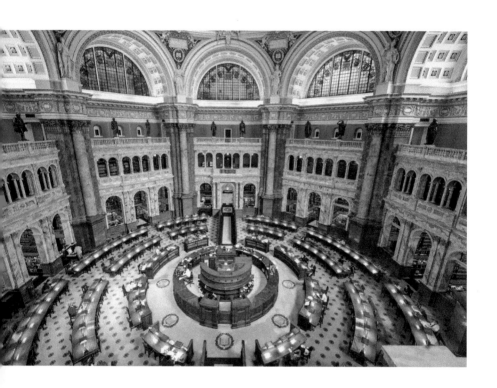

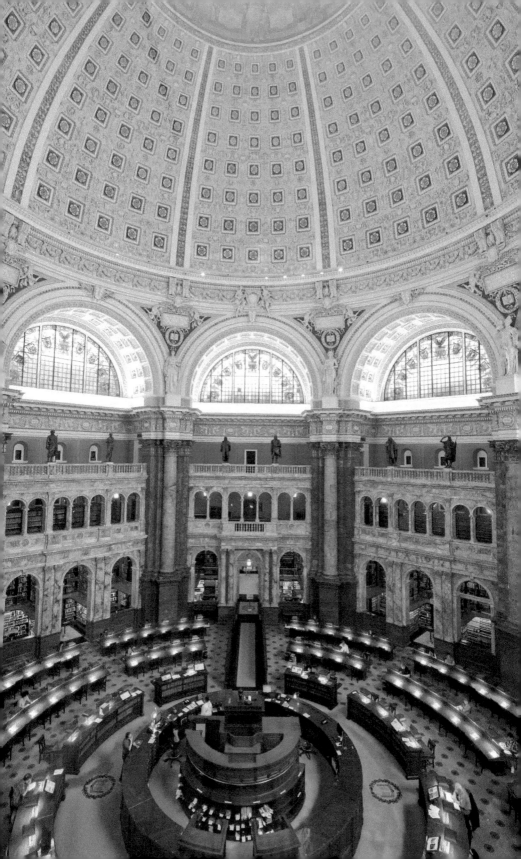

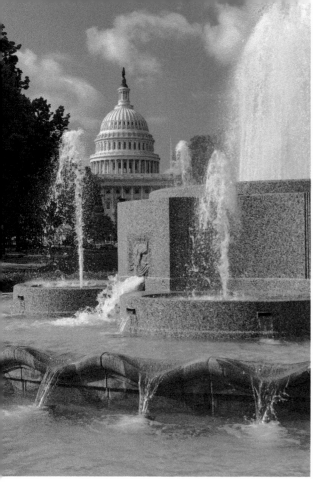

Senate Fountain

in Senate Park offers a lesser-known view of the U.S. Capitol.

Located directly north of the iconic dome., the fountains was completed in 1932. A hexagonal granite monolith has high jets of water spouting from its center, and is surrounded by six smaller jets on a lower level with lion-head spouts.

✉ **Addr:**	Senate Park, Washington DC 20001	♀ **Where:**	38.89469 -77.008994
❓ **What:**	Fountain	◑ **When:**	Afternoon
👁 **Look:**	South	↔ **Far:**	0.55 km (0.34 miles)

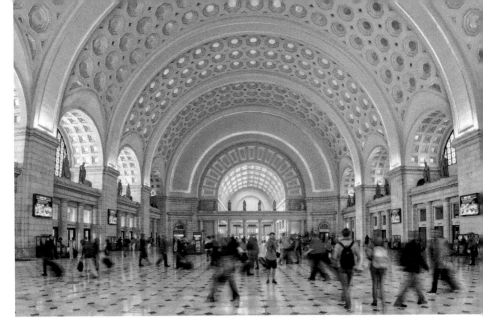

Washington Union Station is Amtrak's second-busiest station and its headquarters. Trains from the south arrive through a 4,033-foot twin-tube tunnel under Capitol Hill, and an 898-foot long subway under Massachusetts Avenue.

Opened in 1907, the monumental structure was designed by famed Chicago architect Daniel Burnham, based on buildings in Rome: the vaulted interior draws from the Baths of Diocletian and the main façade expands on the Arch of Constantine.

Union Station Plaza (Columbus Circle) features the *Columbus Fountain* by Lorado Taft (1912) and a twice-size replicate of the Liberty Bell called *Freedom Bell, American Legion.*

✉ **Addr:**	50 Massachusetts Ave NE, Washington DC 20002	♀ **Where:**	38.896097 -77.006655
❷ **What:**	Station	◕ **When:**	Afternoon
◉ **Look:**	North-northeast	W **Wik:**	Washington_Union_Station

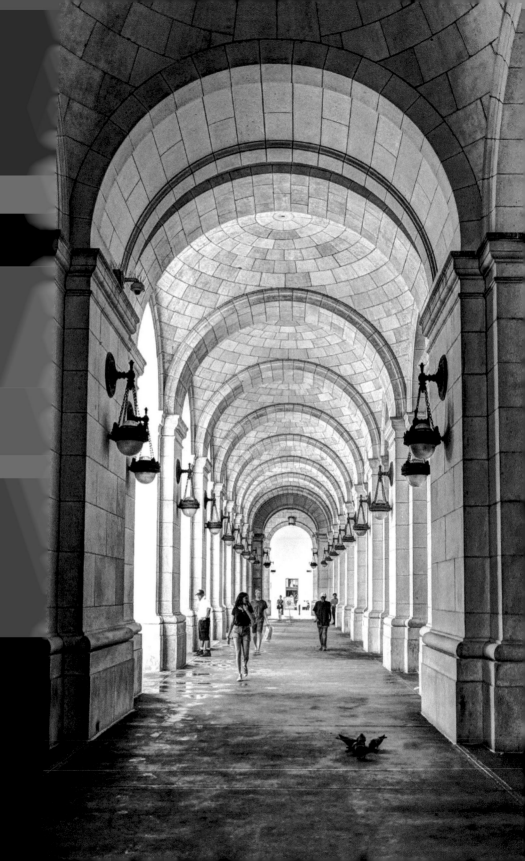

Washington, DC
Union Station

Union Station Drive Northeast

Columbus Cir NE

Delaware Avenue

Columbus Cir

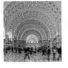 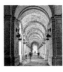 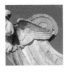 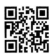

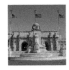 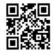 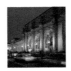

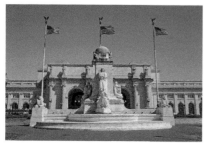

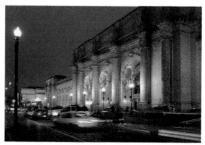

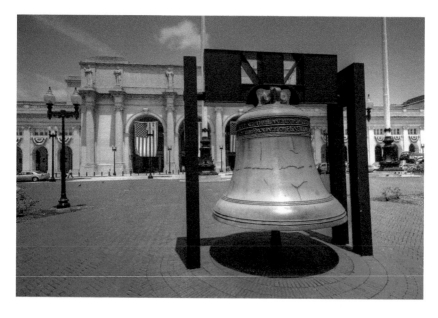

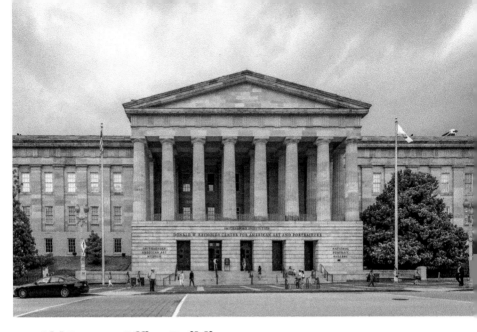

The **Old Patent Office Building** houses two Smithsonian Institution museums: the National Portrait Gallery and the Smithsonian American Art Museum (SAAM).

Located halfway between the Capitol and the White House, the building was designed by Robert Mills in the Greek Revival style, with porticos modeled after the Parthenon in Athens. Completed in 1867, the building housed the Patent Office until 1932, and was given to the Smithsonian in 1958.

✉ **Addr:**	600 7th St NW, Washington DC 20004	♀ **Where:**	38.896967 -77.022962
❓ **What:**	Building	☽ **When:**	Afternoon
👁 **Look:**	North	W **Wik:**	Old_Patent_Office_Building

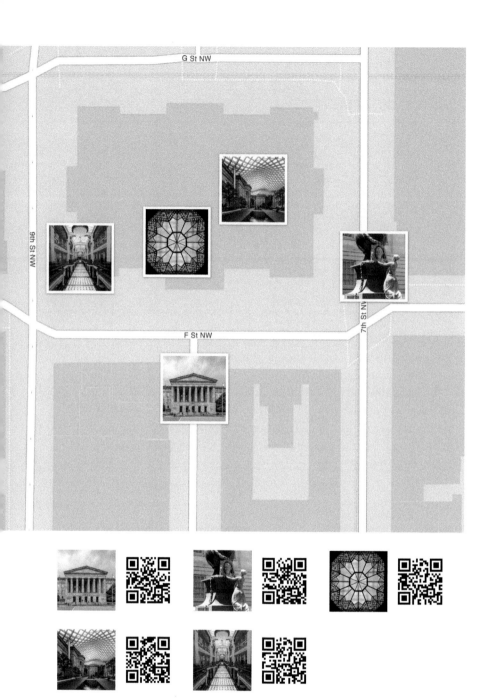

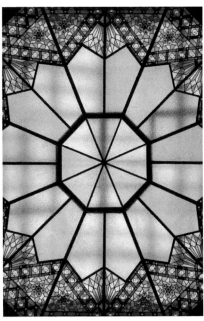

Above left: the Daguerre Memorial on the east side. Skylight.
Below left: Kogod Courtyard, National Portrait Gallery. Below right: Luce
Foundation Center for American Art, Smithsonian American Art Museum.

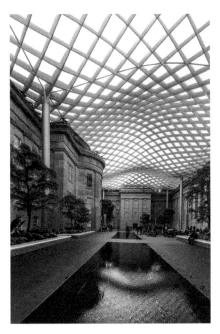
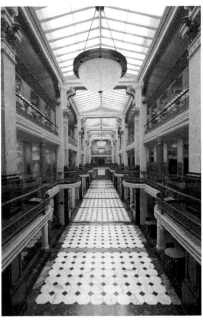

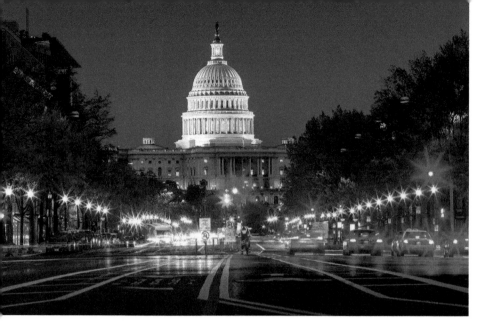

Pennsylvania Avenue and the U.S. Capitol at dusk, from the intersection with 9th Street NW.

✉ **Addr:**	Pennsylvania Ave at 9th, Washington DC 20001	♀ **Where:**	38.893843 -77.023827
When:	Anytime	◉ **Look:**	East-southeast
W **Wik:**	Pennsylvania_Avenue		

The Lone Sailor is a 1987 bronze sculpture by Stanley Bleifeld, at the United States Navy Memorial. About fifteen copies are distributed around the country, including overlooking the Golden Gate Bridge in California, and Pearl Harbor in Hawaii.

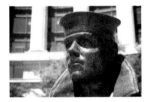

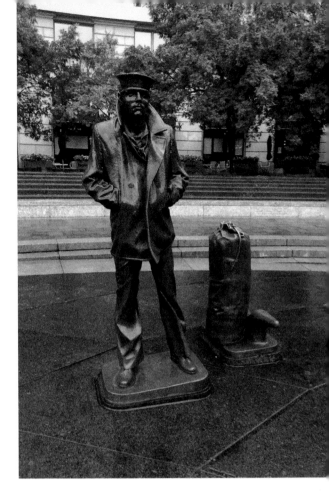

✉ **Addr:**	801 Pennsylvania Ave NW, Washington DC 20004	♀ **Where:**	38.89417 -77.02306	
❓ **What:**	Statue	☾ **When:**	Afternoon	
👁 **Look:**	North	W **Wik:**	The_Lone_Sailor	

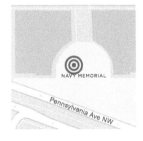

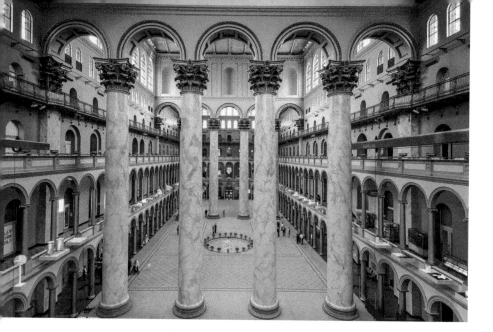

The **National Building Museum** showcases "architecture, design, engineering, construction, and urban planning" in a magnificent setting. The 1887 Pension Building is a Renaissance Revival structure made from 15 million bricks and designed by Montgomery Meigs. The Great Hall has spectacular interior columns.

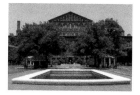

Nearby is the National Law Enforcement Officers Memorial with a reflecting pool and bronze sculptures of a pride of lions.

✉ **Addr:**	401 F St NW, Washington DC 20001	♀ **Where:**	38.896448 -77.017508
❓ **What:**	Museum	☽ **When:**	Morning
👁 **Look:**	North	W **Wik:**	National_Building_Museum

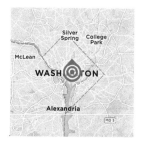

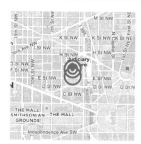

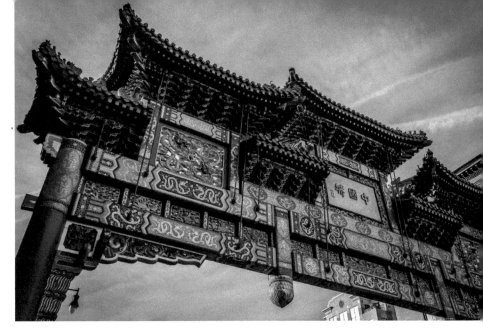

Friendship Archway in Chinatown is a traditional Chinese gate designed by local architect Alfred H. Liu. Unveiled in 1986, the Archway has seven roofs, 7000 tiles, and 272 painted dragons in the style of the Ming and Qing dynasties. According to the plaque next to the arch, it is the largest such single-span archway in the world.

Nearby is the Gallery Place-Chinatown metro station (beneath the Capital One Arena) with an impressive concrete ceiling, conveniently photographed from a bridge.

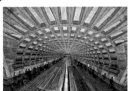

✉ **Addr:**	807 7th St NW, Washington DC 20001	♀ **Where:**	38.899869 -77.021771
❓ **What:**	Gate	◑ **When:**	Afternoon
👁 **Look:**	Southeast	W **Wik:**	Friendship_Archway

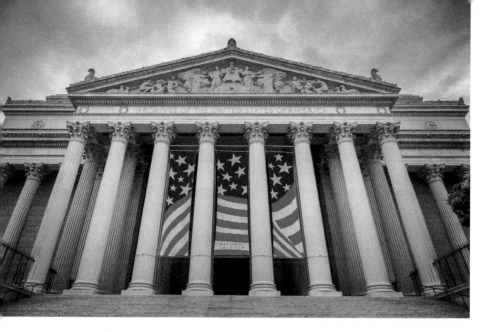

The **National Archives Building** displays to the public the original copies of the three main formative documents of the United States and its government: the Declaration of Independence, the Constitution, and the Bill of Rights. You can also see the Articles of Confederation, the Louisiana Purchase Treaty, the Emancipation Proclamation, and an original version of the 1297 Magna Carta. Photography is not permitted inside the museum.

Designed by prolific DC architect John Russell Pope, the building opened in 1935 as a temple of history. A larger facility, known as Archives II, opened in 1993 in Maryland.

✉ **Addr:**	700 Pennsylvania Ave NW, Washington DC 20408	♀ **Where:**	38.892244 -77.022938
❓ **What:**	Building	☾ **When:**	Afternoon
👁 **Look:**	North	W **Wik:**	National_Archives_Building

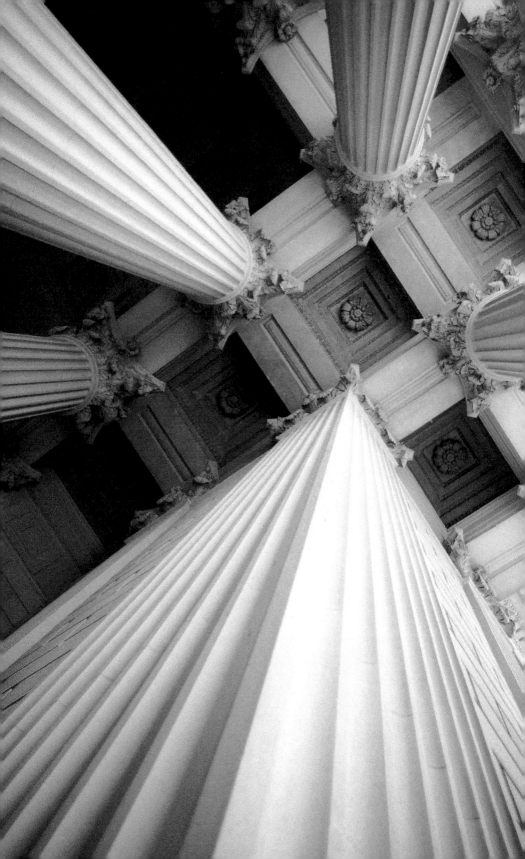

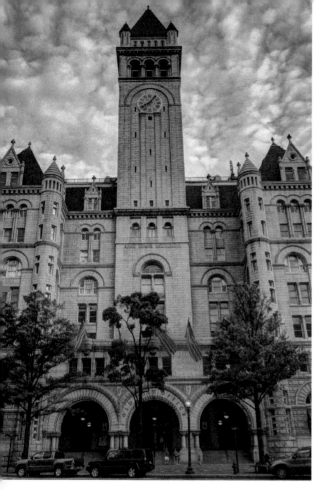

The **Old Post Office** is a Beaux Arts structure from 1899 and home to the Trump International Hotel Washington, D.C., which opened in September 2016.

The 315-foot (96 m) high Clock Tower houses the "Bells of Congress", replicas of bells in Westminster Abbey, and offers panoramic views of the city and its surroundings on an observation level. Inside is a glass covered atrium and elevators with cages of highly intricate wrought iron.

In front of the Old Post Office, to the NW, is a statue of Benjamin Franklin.

✉ **Addr:**	1100 Pennsylvania Ave NW, Washington DC 20004	📍 **Where:**	38.894571 -77.027598	
❓ **What:**	Building	🕐 **When:**	Afternoon	
👁 **Look:**	North	W **Wik:**	Old_Post_Office_(Washington,_D.C.)	

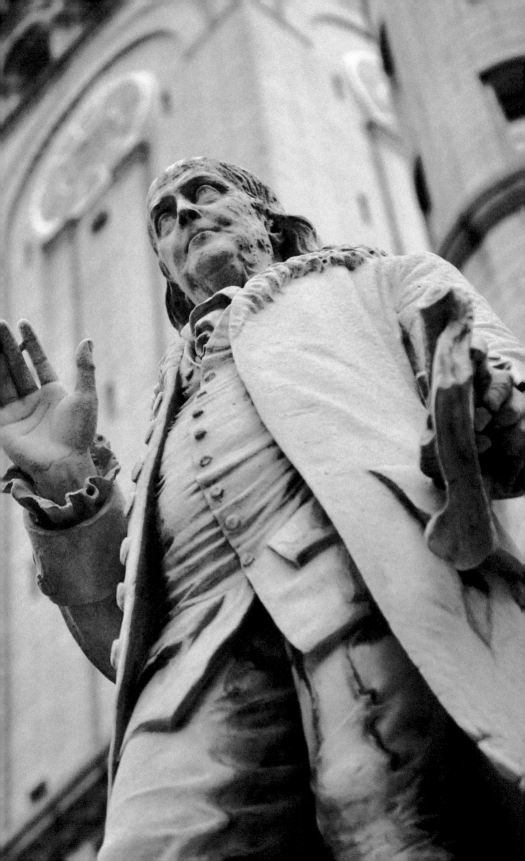

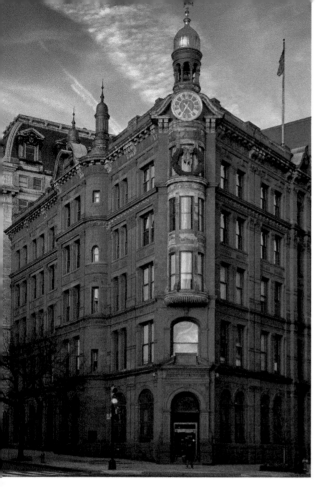

The **National Savings and Trust Company** is a historic bank building built from 1888. The Queen Anne Style building is constructed in red brick, and elaborately detailed with copper and terra cotta.

The slightly triangular structure is a block east of the north side of the White House, in the Fifteenth Street Financial Historic District.

✉ **Addr:**	1445 New York Ave NW, Washington DC 20005	♀ **Where:**	38.898716 -77.033707
❷ **What:**	Building	◔ **When:**	Afternoon
◉ **Look:**	North-northeast	W **Wik:**	National_Savings_and_Trust_Company

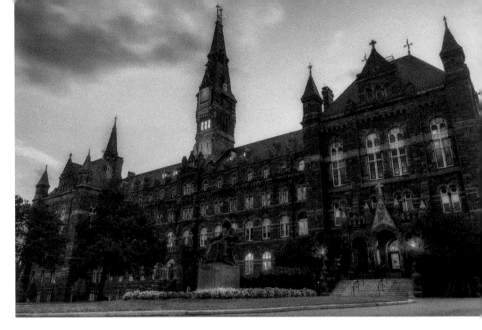

Georgetown University is a private research university founded in 1789 by Jesuit John Carroll. A statue of him resides outside Healy Hall (above), built 1879 in a Gothic/Romanesque/Renaissance style. In the south tower is Riggs Library, a four-story, cast-iron Victorian wonder.

On the edge of the campus is a flight of steps used in the movie The Exorcist (1973), where Father Damien Karras died (corner of Prospect St NW and 36th St NW).

The port of Georgetown predates D.C. by 40 years. Founded in 1751, Georgetown remained a separate municipality until 1871, when the United States Congress created a new consolidated government for the whole District of Columbia.

✉ **Addr:**	3700 O St NW, Washington DC 20057	♀ **Where:**	38.907604 -77.072258
❷ **What:**	University	◑ **When:**	Afternoon
👁 **Look:**	North	W **Wik:**	Georgetown_university

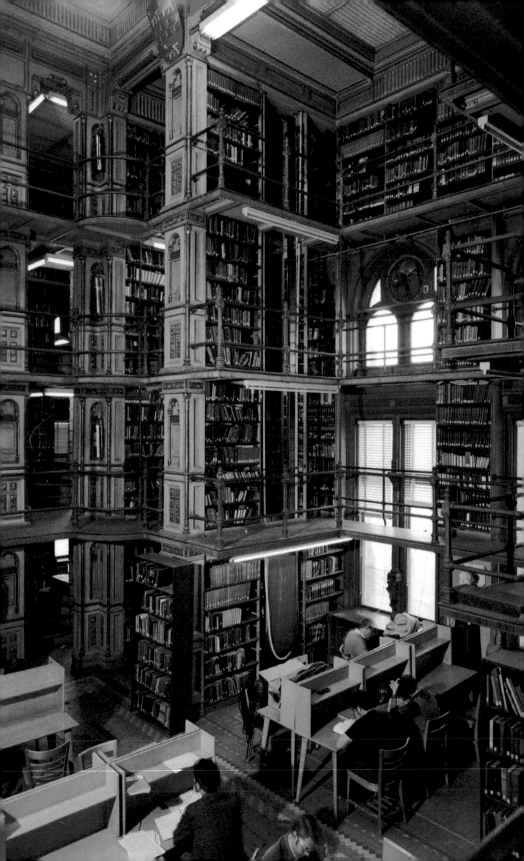

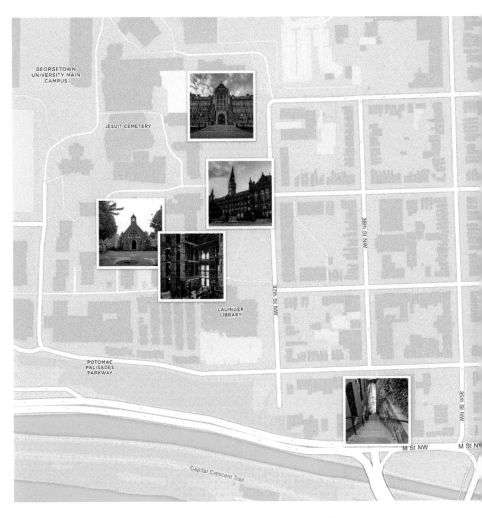

GEORGETOWN UNIVERSITY MAIN CAMPUS

JESUIT CEMETERY

36th St NW

37th St NW

LAUINGER LIBRARY

POTOMAC PALISADES PARKWAY

35th St NW

M St NW

M St N

Capital Crescent Trail

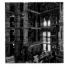

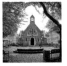

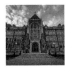

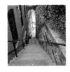

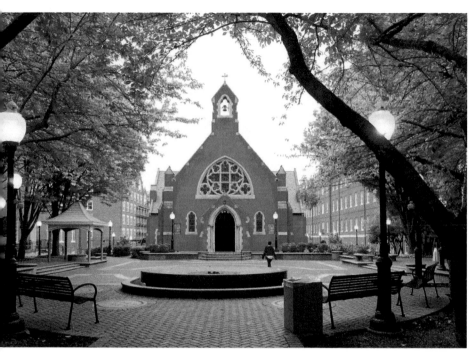

Previous: Riggs Library in Healy Hall. Above: Dahlgren Chapel of the Sacred Heart.

Below: White-Gravenor Hall. Right: "The Exorcist" steps.

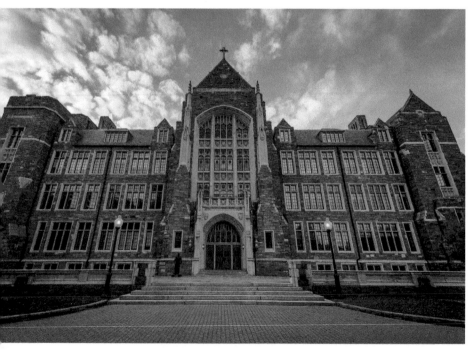

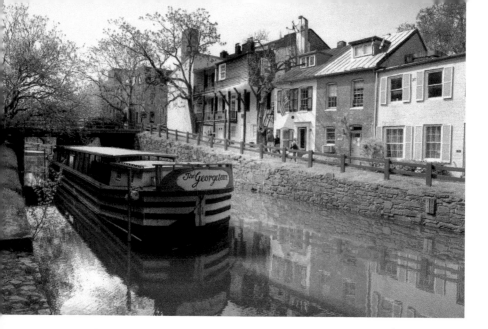

The **Chesapeake and Ohio Canal** is a scenic ribbon of water though Georgetown and a National Historic Park.

From 1831 to 1924, the C&O Canal brought coal and other materials 184 miles (297 km) from the Allegheny Mountains in the northwest to Washington, D.C., bypassing rapids on the Potomac River.

The most photogenic spot is Lock 4 (pictured above) at 31st Street, where the tow path gently rises beside colorful row houses. From near this point, the Washington City Canal extended through the future National Mall to the foot of the United States Capitol.

The canal is being renovated and may not have water.

✉ **Addr:**	C&O Canal Towpath, Washington DC 20007	♥ **Where:**	38.904138 -77.060557
❷ What:	Canal	**⊙ When:**	Morning
👁 Look:	West-northwest	W **Wik:**	Chesapeake_and_Ohio_Canal

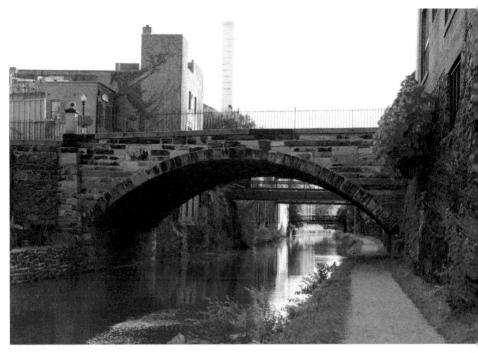

Above: One block west of Lock 4 is the arched Wisconsin Avenue Bridge, which leads north to the main shopping area at M Street. *Below:* One block east of Lock 4 and just north on 30th Street are these picturesque row houses.

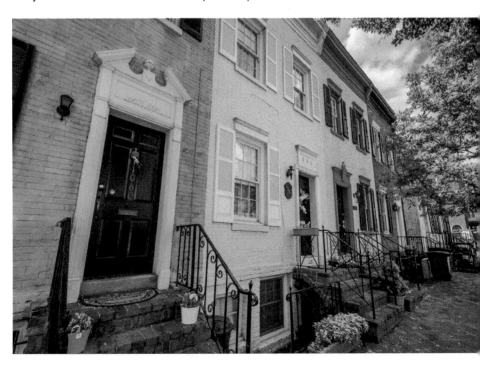

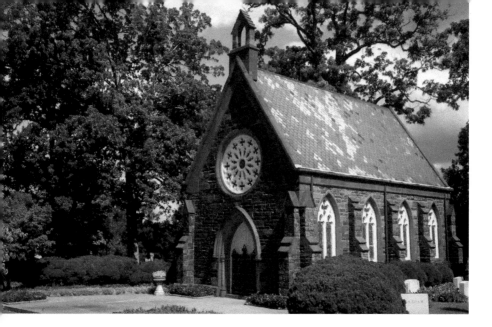

The **Oak Hill Cemetery Chapel**, also known as the Renwick Chapel or James Renwick Chapel, is a Gothic Revival church designed by James Renwick, Jr. in 1850, after he had finished the Smithsonian Castle.

✉ **Addr:**	2900 R St NW, Washington DC 20007	♀ **Where:**	38.912815 -77.058754
❓ **What:**	Building	◷ **When:**	Afternoon
👁 **Look:**	East	W **Wik:**	Oak_Hill_Cemetery_Chapel_(Washington,_D.C.)

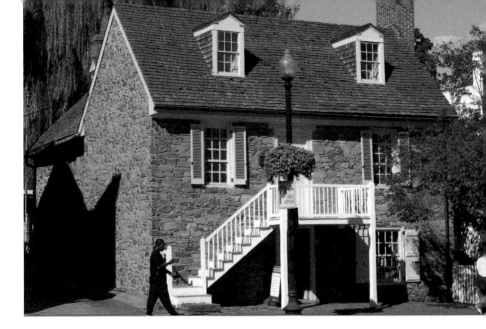

The **Old Stone House** is the Washington's oldest unchanged building and only Pre-Revolutionary colonial building on its original foundation. Built in 1765 with local blue granite and fieldstone, Old Stone House is located at 3051 M Street in Georgetown.

✉ **Addr:**	3057 M St NW, Washington DC 20007	♥ **Where:**	38.90523 -77.060435
❓ What:	Building	**⏱ When:**	Afternoon
👁 Look:	North-northeast	**W Wik:**	Old_Stone_House_(Washington,_D.C.)

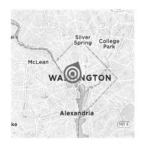

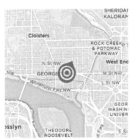

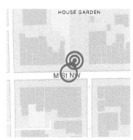

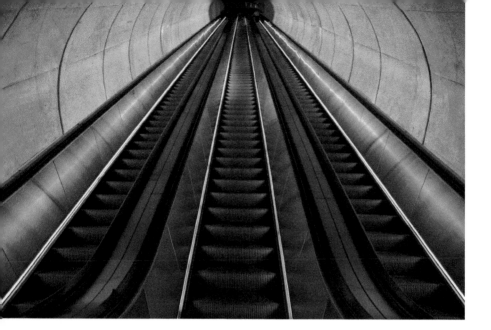

Dupont Circle Station features two escalator shafts that showcase the modern brutalist work of Chicago architect Harry Weese..

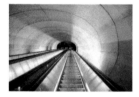

The south entrance escalators offer a dramatic view from the base (above), and the north entrance (left and right) descends through an oval concrete tunnel.

Dupont Circle opened in 1977 as the underground system's third portal, after Union Station and Farragut North. The network now includes 91 stations, six lines and 117 miles (188 km) of route.

✉ **Addr:**	Connecticut Ave NW, Washington DC 20036	♀ **Where:**	38.908738 -77.043284
❓ **What:**	Metro station	◑ **When:**	Anytime
👁 **Look:**	South	W **Wik:**	Dupont_Circle_station

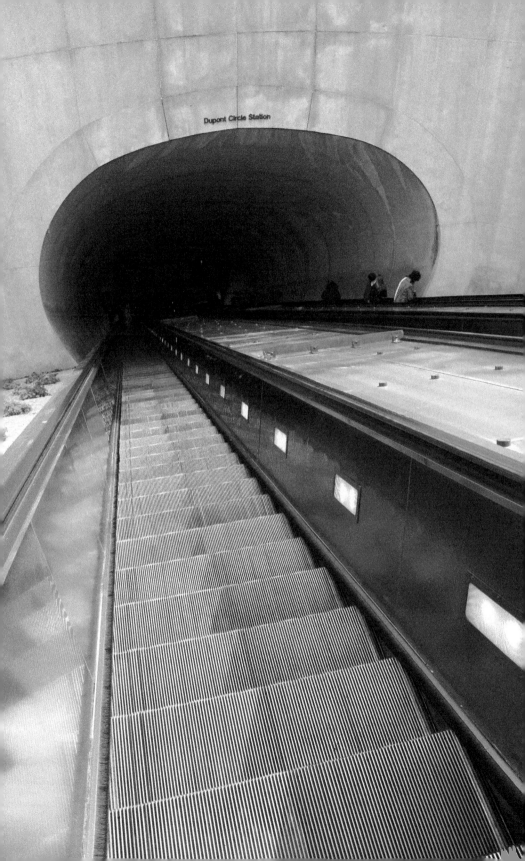

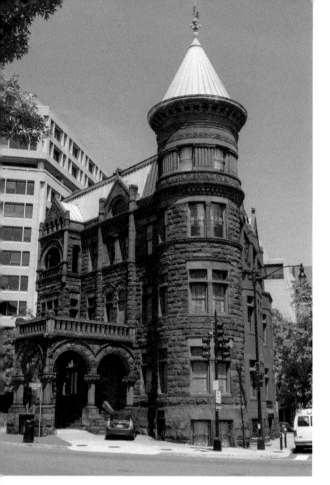

Heurich House Museum, also known as the Christian Heurich Mansion or Brewmaster's Castle, is a Gilded Age mansion in the Dupont Circle neighborhood. It was built in 1892-94 by architect John Granville Meyers for German immigrant and brewer Christian Heurich, the District's largest private employer at the time.

✉ **Addr:**	1307 New Hampshire Ave NW, Washington DC 20036	♀ **Where:**	38.907946 -77.045071
❷ **What:**	Museum	◑ **When:**	Afternoon
◉ **Look:**	East	W **Wik:**	Heurich_House_Museum

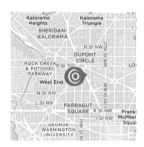
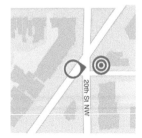

The **Mahatma Gandhi Memorial** is a public monument of Mahatma Gandhi, installed in front of the Embassy of India. Unveiled in 2000, the statue by Gautam Pal in Kolkata depicts the renowned activist in ascetic garb, on his 1930 march against a salt tax in India.

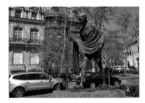

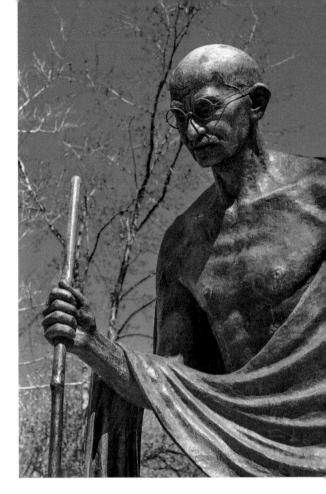

✉ **Addr:**	1600 21st St NW, Washington DC 20009	♀ **Where:**	38.91099 -77.047006
❓ **What:**	Memorial	⏲ **When:**	Afternoon
👁 **Look:**	Northeast	W **Wik:**	Mahatma_Gandhi_Memorial_(Washington,_D.C.)

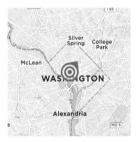

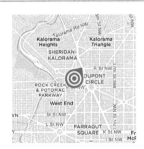

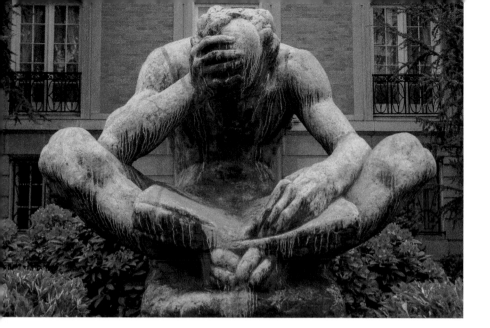

St. Jerome the Priest looks how I feel. This bronze statue by Ivan Meštrović is at the front of the Croatian Embassy on Embassy Row. Saint Jerome was born on the territory of modern Croatia and is honored here as the "greatest doctor of the church." He made the first Latin translation of the Hebrew Bible.

✉ **Addr:**	2343 Massachusetts Ave NW, Washington DC 20008	♀ **Where:**	38.913409 -77.052333
❓ **What:**	Sculpture	☾ **When:**	Afternoon
👁 **Look:**	Northeast	W **Wik:**	St._Jerome_the_Priest_(Meštrović)

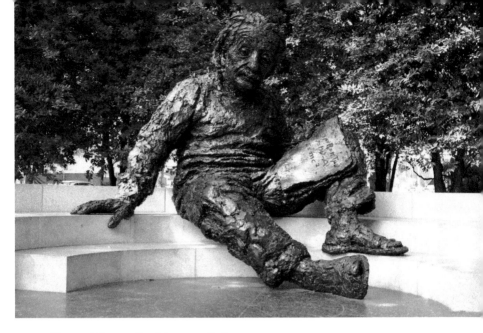

The **Albert Einstein Memorial** is a monumental bronze statue depicting Albert Einstein seated with manuscript papers that include expression $E = mc^2$. The 1979 sculpture by sculptor Robert Berks is at the southwest corner of the grounds of the National Academy of Sciences, where Einstein was a member.

On the back of the bench are quotations including "As long as I have any choice in the matter, I shall live only in a country where civil liberty, tolerance, and equality of all citizens before the law prevail."

✉ **Addr:**	2101 Constitution Ave NW, Washington DC 20418	♀ **Where:**	38.892371 -77.048434
❓ **What:**	Statue	🕑 **When:**	Morning
👁 **Look:**	North-northwest	W **Wik:**	Albert_Einstein_Memorial

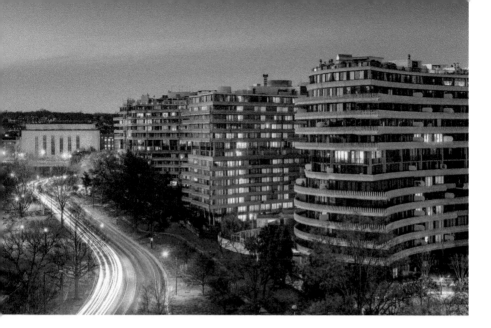

The **Watergate complex** is known for the "Watergate scandal," which led to President Richard Nixon's resignation in 1974. The suffix "-gate" is now synonymous with political scandals.

The complex of six buildings includes an office tower at 2600 Virginia Avenue on the northeast side. In 1972, the sixth floor was occupied by the headquarters of the Democratic National Committee (DNC) which was secretly being wiretapped by Nixon's re-election campaign. During a burglary to replace a malfunctioning phone tap and collect more information, five burglars were arrested and the ensuing investigation led right to the top.

The above photo shows the hotel portion of the building in the center, and is taken from the roof-top plaza of the JFK Center.

✉ **Addr:**	2558 Virginia Ave NW, Washington DC 20037	♀ **Where:**	38.896803 -77.056003
❷ **What:**	Building	◷ **When:**	Anytime
◉ **Look:**	North	W **Wik:**	Watergate_complex

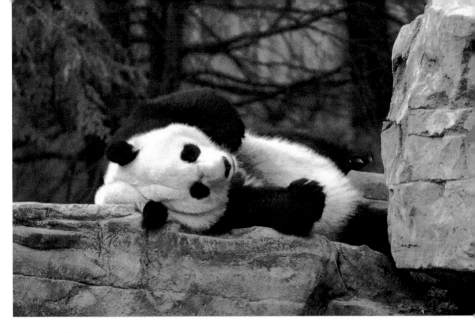

The **National Zoo** is home to two adult giant pandas, named Mei Xiang (adult female) and Tian Tian (adult male). A cub called Bei Bei was born in 2015 and may leave for China in 2019/20.

The pandas generally have outside access until early afternoon. There is also an indoor panda house. Arrive early to avoid crows and lines. Flash photography is permitted, tripods are prohibited.

Founded in 1889 as part of the Smithsonian Institution, the National Zoological Park (official name) is in Rock Creek Park, about 2.3 miles (3.4 km) north of the White House.

✉ **Addr:**	3001 Connecticut Ave. NW, Washington DC 20008	♥ **Where:**	38.931153 -77.052790
❷ **What:**	Zoo	◑ **When:**	Afternoon
◉ **Look:**	North	W **Wik:**	National_Zoological_Park_(United_States)

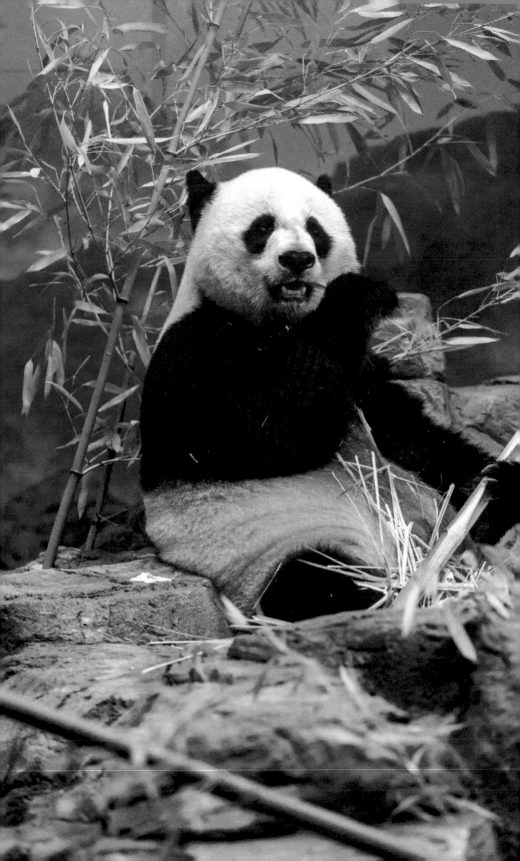

The **Washington National Cathedral** is the second-largest church building in the United States. Officially the Cathedral Church of Saint Peter and Saint Paul in the City and Diocese of Washington, the neo-Gothic building is closely modeled on English Gothic style of the late fourteenth century.

The central *Gloria in Excelsis Tower*, at 676 ft (206 m) above sea level, is the highest point in Washington. There is an observatory in the west-end towers with sweeping views of the city.

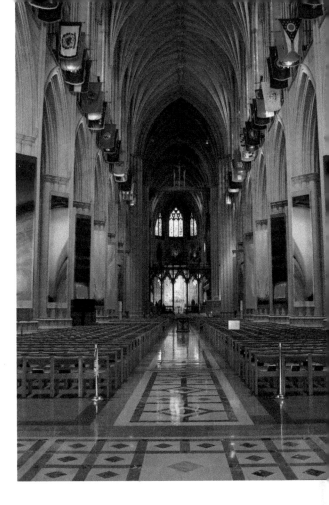

✉ **Addr:**	3101 Wisconsin Ave NW, Washington DC 20016	♀ **Where:**	38.93086 -77.0728721
❓ **What:**	Cathedral	◑ **When:**	Afternoon
👁 **Look:**	East	W **Wik:**	Washington_National_Cathedral

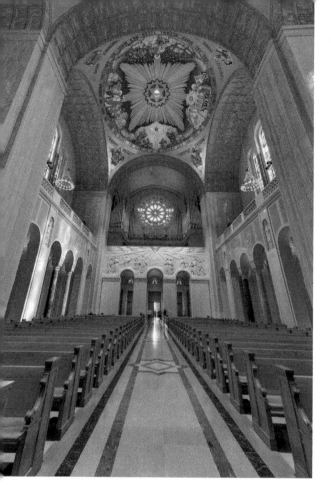

The **Basilica of the National Shrine of the Immaculate Conception** is the largest Catholic church in the United States and in North America. Its construction of Neo-Byzantine architecture began in 1920 with renowned contractor John McShain while the *Trinity Dome* mosaic with 24 tons of Venetian glass marked its completion in 2017.

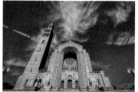

✉ **Addr:**	400 Michigan Ave NE, Washington DC 20017	♀ **Where:**	38.932436 -77.000443
❷ **What:**	Church	◑ **When:**	Morning
◉ **Look:**	North	W **Wik:**	Basilica_of_the_National_Shrine_of_the_Immaculate_Conception

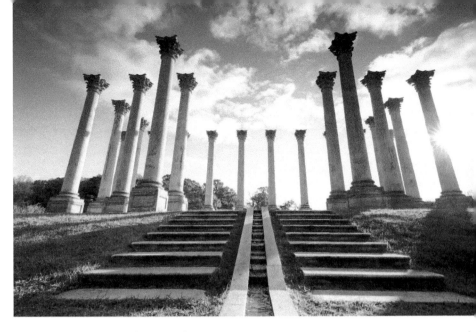

The **National Capitol Columns** originally supported the old East Portico of the United States Capitol (1828). The 23 Corinthian columns were removed during expansion of the Capitol in 1958 and now stand 2.2 miles (3.5 km) northeast away on a hill overlooking a reflecting pool at the U.S. National Arboretum.

Established in 1927, the 446-acre (1.80 km2) botanical park features aquatic plants, flowering trees, Bonsai trees, and a herb garden.

✉ **Addr:**	3501 New York Ave NE, Washington DC 20002	♀ **Where:**	38.910219 -76.967722
☽ **When:**	Afternoon	👁 **Look:**	East
Ⓦ **Wik:**	National_Capitol_Columns		

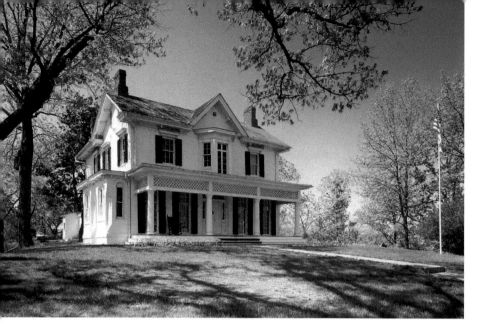

Frederick Douglass House belonged to one of the most prominent African Americans of the 19th century. After escaping from slavery in Maryland, Douglass became a national leader of the abolitionist movement in Massachusetts and New York, gaining note for his oratory and incisive antislavery writings.

Douglass and his wife lived in this house, which they named Cedar Hill, from 1877 until his death in 1895. Perched high on a hilltop, the site also offers a sweeping view of the D.C. skyline.

Nearby is a reconstruction of Douglass' "Growlery", a small stone building in which he secluded himself while writing and studying.

✉ **Addr:**	1411 W St SE, Washington DC 20020	♀ **Where:**	38.863643 -76.984884	
❓ **What:**	Historic house	◔ **When:**	Morning	
👁 **Look:**	Southwest	W **Wik:**	Frederick_Douglass_National_Historic_Site	

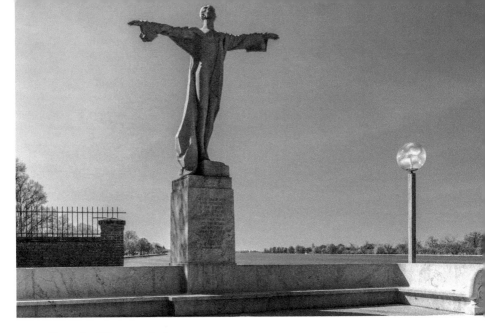

The **Titanic Memorial** is a granite statue in southwest Washington, D.C., that honors the men who gave their lives so that women and children might be saved during the RMS Titanic disaster. The thirteen-foot-tall figure is of a partly clad male figure with arms outstretched standing on a square base.

✉ **Addr:**	Southwest Waterfront Park, Washington DC 20024	♀ **Where:**	38.871999 -77.019307	
❓ **What:**	Memorial	🕐 **When:**	Afternoon	
👁 **Look:**	South	W **Wik:**	Titanic_Memorial_(Washington,_D.C.)	

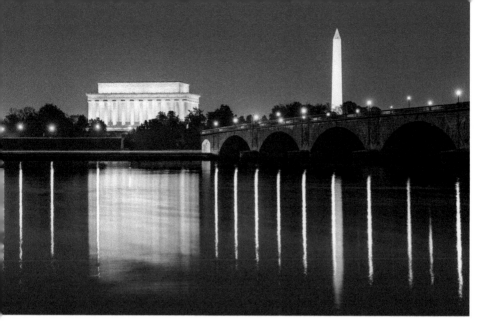

Washington skyline from Columbia Island. Across (and in)
the Potomac River is Columbia Island, renamed in 1968 as Lady Bird
Johnson Park. The partially-man-made island has a 1,000-foot-long (350
m) stretch of the Mt Vernon Trail with views east of the Arlington
Memorial Bridge, the Lincoln Memorial and the Washington
Monument.

The view above is taken at dusk from the
northeast corner of the Arlington Bridge, while
the smaller image (including the U.S. Capitol)
is taken from a short walk north. There is no
roadside parking here; the nearest parking
(and metro station) is 2/3 mile away (1 km) at
Arlington National Cemetery.

✉ **Addr:**	Potomac Park, Washington DC 20566	♀ **Where:**	38.8877195 -77.0599406	
❷ **What:**	Views	◷ **When:**	Anytime	
◉ **Look:**	East-northeast	W **Wik:**	Columbia_Island_(District_of_Columbia)	

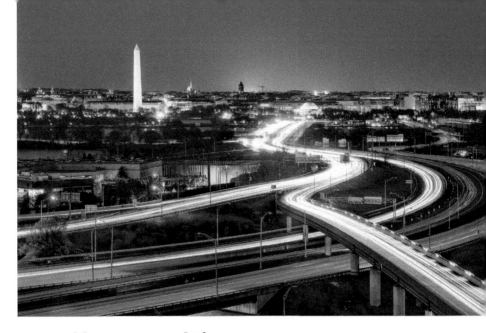

The **DoubleTree Crystal City** hotel has spectacular views from a rooftop deck on the 14th floor and the SkyDome Restaurant, the only revolving rooftop restaurant with views of Washington, D.C. monuments.

This dusk shot looks northeast with Route 1 (white) and I-395 (red) crossing the Potomac to the Jefferson Memorial and the Washington Monument obelisk. You can also see the U.S. Capitol, the Pentagon, and the Air Force Memorial.

✉ **Addr:**	300 Army Navy Dr, Arlington VA 22202	♀ **Where:**	38.864025 -77.052773
◑ **When:**	Anytime	◉ **Look:**	North-northeast
↔ **Far:**	3.21 km (1.99 miles)		

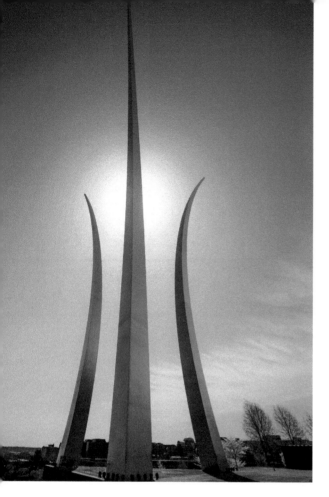

The **United States Air Force Memorial** honors the service of the personnel of the United States Air Force and its heritage organizations.

The memorial is on Joint Base Myer–Henderson Hall, near The Pentagon and Arlington National Cemetery.

Dedicated in 2006, the design by American architect James Ingo Freed includes three stainless steel spires up to 270 feet (82 m), arcing away like the contrails of fighter jets.

Observing is an Honor Guard of four 8-foot-tall (2.4 m) bronze statues, sculpted by Zenos Frudakis.

✉ **Addr:**	1 Air Force Memorial Dr, Arlington VA 22204	♀ **Where:**	38.868152 -77.066466	
❓ **What:**	Memorial	☾ **When:**	Afternoon	
👁 **Look:**	North-northeast	W **Wik:**	United_States_Air_Force_Memorial	

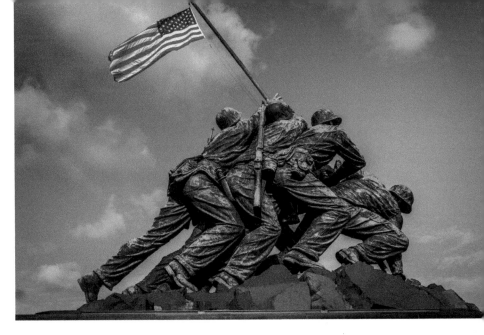

The **United States Marine Corps War Memorial** was inspired by the iconic 1945 photograph of six Marines raising a U.S. flag atop Mount Suribachi during the Battle of Iwo Jima in World War II.

Based on the picture taken by Associated Press combat photographer Joe Rosenthal, sculptor Felix de Weldon created a colossal bronze group with figures 32 feet (9.8 m) tall.

The memorial is located north of Arlington National Cemetery in Arlington Ridge Park, due west of the U.S. Capitol, on a high ridge with a view of the Washington Monument and the Capitol.

✉ **Addr:**	Arlington National Cemetery, Arlington VA 22209	♀ **Where:**	38.890443 -77.069944	
❷ **What:**	Memorial	◔ **When:**	Afternoon	
◉ **Look:**	East	W **Wik:**	Marine_Corps_War_Memorial	

The **Netherlands Carillon** was a gift from the people of the Netherlands to the people of the United States in 1954. Springtime brings tulips for a Dutch-looking foreground.

The belltower is in Arlington Ridge Park, just north of Arlington Cemetery, on a slight hill which affords a view of the Washington skyline.

✉ **Addr:**	North Marshall Drive, Arlington VA 22209	♀ **Where:**	38.888457 -77.069116
❓ **What:**	Tower	☽ **When:**	Morning
👁 **Look:**	Southwest	W **Wik:**	Netherlands_Carillon

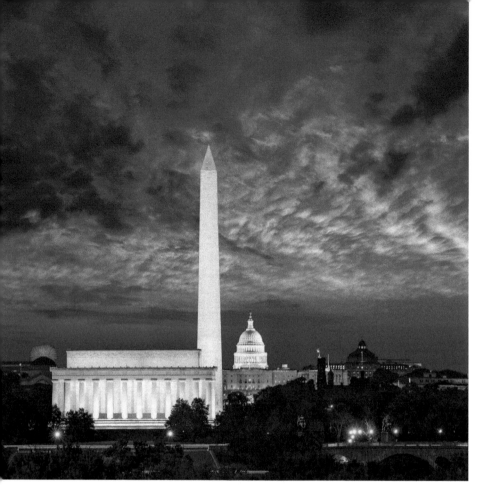

Washington skyline from Netherlands Carillon.

✉ **Addr:**	Netherlands Carillon, Arlington VA 22209	📍 **Where:**	38.888240 -77.069239
❓ **What:**	Skyline	🌓 **When:**	Sunrise
👁 **Look:**	East	↔ **Far:**	2.95 km (1.83 miles)

Arlington area > Arlington County > Rosslyn > Arlington Ridge Park > Netherlands Carillon > Washington skyline

Top of the Town has the best skyline view of Washington, D.C.

Located in the Rosslyn section of Arlington, one block west of the Iwo Jima Memorial, within walking distance from the Rosslyn Metro Station, this penthouse event space has a glass-walled room and outdoor terrace.

A more horizontal view can be taken from The Observation Deck at CEB Tower at 1201 Wilson Blvd., about 1/2 a mile (800 m) north.

Nearby, is the garage where Bob Woodward of *The Washington Post* met "Deep Throat" (Mark Felt, second in command at the FBI) during the Watergate Investigation. (As of 2019, the complex is planned to be demolished). A plaque marks the spot at 1820 N Nash Street.

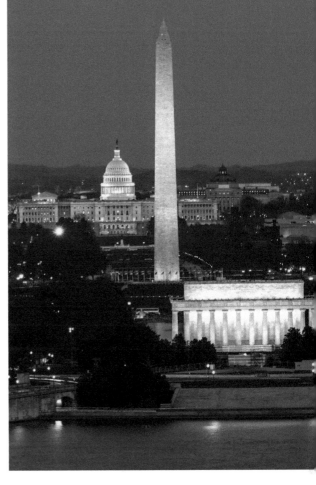

✉ **Addr:**	1400 14th Street N, Arlington VA 22209	♥ **Where:**	38.8893627 -77.0729113
❓ **What:**	Skyline	◑ **When:**	Anytime
👁 **Look:**	East	↔ **Far:**	3.26 km (2.02 miles)

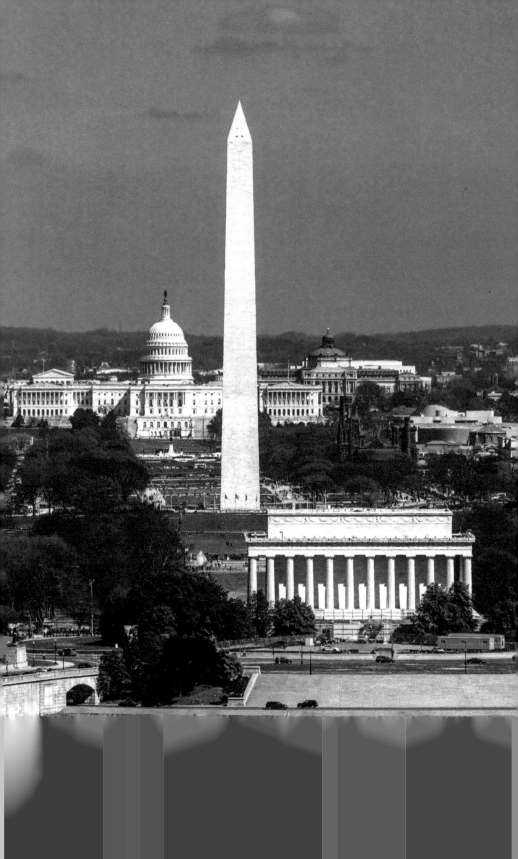

Credits

Thank you to the many wonderful people and companies that made their work available to use in this guide.

Photo key: The number is the page number. The letters reference the position on the page, the distributor and the license. Key: a:CC-BY-SA; b:bottom; c:center; d:CC-BY-ND; f:Flickr; g:GNU Free Documentation License; h:Shutterstock standard license; l:public domain; s:Shutterstock; t:top; w:Wikipedia; y:CC-BY.

Cover image by Jon Bilous/Shutterstock. Back cover image by Jon Bilous/Shutterstock. Acroterion (127 wa); Agnosticpreacherskid (64b, 130, 144t, 157 sh); Leonid Andronov (43, 55t, 59t, 97t sh); Arak7 (95 sh); Atomazul (106t sh); Roman Babakin (62, 72t sh); Tono Balaguer (24b, 25, 80, 104t, 143t, 166t fa); Elvert Barnes (78 wy); Alexander Barth (146 sh); A G Baxter (124t, 124b fy); Josh Berglund (47 fy); David Berkowitz (78 sh); Jon Bilous (56, 67, 76, 131t, 140b, 143b sh); Kristi Blokhin (122 wa); Bluesnote (129t sh); Stephen Bonk (77t wl); Jack Boucher (138 sh); Bryan Brazil (120 fy); John Brighenti (22t sh); Rachelle Burnside (84t sh); Orhan Cam (19t, 21, 24t, 29t, 30t, 33, 91t, 92t, 96t, 101t, 120t, 124b, 135, 137t, 156t wl); Camwow (68 sh); Carolyn M Carpenter (108t sh); Cdrin (35 sh); Checubus (45 sh); Feng Cheng (140t sh); Bill Chizek (156 sh); Cristina Ciochina (151t fy); Ron Cogswell (64t, 115, 149 sh); Erik Cox (159t sh); Rob Crandall (39, 71, 78 sh); Ryan Crupnick (58b sh); Cvandyke (29b, 69t, 94t fy); Korlis Dambrons (62b wy); Dbking (127 sh); Bumble Dee (93 sh); Songquan Deng (23t, 54t sh); Colin Dewar (132t, 133 sh); Dibrova (34t, 44t sh); Celso Diniz (136t sh); Le Do (103 sh); Mark Van Dyke (157t wa); Mina Elias (155t wa); Difference Engine (148t, 148 sh); Evdoha_spb (67t, 68b sh); F11photo (26t, 28b, 48t, 48, 60t, 67b, 90, 98t, 99, 101c, 103, 128t sh); Ck Foto (116c, 119 wa); Zack Frank (127 sh); Vlad G (163 wl); Georgekutty (150t fy); That Stormy Girl (62 sh); Sr Green (46t sh); Joseph Gruber (165t wl); Gryffindor (71 sh); Steve Heap (49t, 50t, 91c sh); Helen89 (71b wa); Hillmanhan (73 sh); Valerii Iavtushenko (112t, 113 sh); Ambient Ideas (111 sh); Ikehayden (124b wa); Ingfbruno (111b, 142t sh); Anton Ivanov (75t sh); Andrea Izzotti (38t, 121t, 131 wa); Jamieadams99 (59 fy); Jareed (78 sh); Kamira (62t fa); Ken_from_md (153 sh); Byron Key (96 sh); James Kirkikis (32 sh); Ken Kistler (129 sh); Kropic1 (107b sh); Marcel Lesch (88t, 89 sh); Felix Lipov (71t, 132 sh); Lucky-photographer (87c, 87b sh); Lewis Tse Pui Lung (51t wa); Mattwade (110c sh); Larry Mccormick (37 sh); Mdogan (160 sh); Andrei Medvedev (79t sh); Lissandra Melo (147 sh); Mervas (63t, 75b sh); Mishella (162t fd); Mr.tindc (127 sh); Muddymari (85 wa); Musikanimal (52t fd); Ncindc (144 sh); Jack Nevitt (163t, 164 wl); Noclip (58 wa); Something Original (145 wa); Otya (145t sh); Adam Parent (93t sh); Sean Pavone (41b, 42t, 91b, 101t, 102t, 109t, 110t, 110b, 118c, 130t, 152t, 160t, 161t wa); Mike Peel (134t sh); Bill Perry (42, 149t sh); Eddie Peterson (141 sh); Philipr (30b sh); Esb Professional (22b wg); Prohibitonions (83b sh); Jerric Ramos (116b, 117 wa); Raul654 (31t sh); Nicolas Raymond (33 wy); Phil Roeder (111t fa); Victor R. Ruiz (58 sh); Rick Sause (83t sh); S.borisov (28t, 82t sh); Rena Schild (116t sh); Ken Schulze (87t fy); Young Shanahan (68 sh); Vivvi Smak (68t wl); Smallbones (158 wl); Walter Smalling (158t sh); Lee Snider (67 sh); Joseph Sohm (146t, 167t sh); Action Sports Photography (107t fy); Sarah Stierch (105 sh); Black Russian Studio (23b sh); Png Studio Photography (125t, 154 fa); Pedro Szekely (65t sh); Tanarch (82c sh); Trekandshoot (111 sh); Trphotos (53t sh); Turtix (41t sh); Oksana Tysovska (58t wl); Uscapitol (36 sh); Vacclav (104 sh); Popova Valeriya (97 sh); Boris Vetshev (82b sh); Cedric Weber (77b sh); Alfred Wekelo (153t sh).

Some text adapted from Wikipedia and its contributors, used and modified under Creative Commons Attribution-ShareAlike (CC-BY-SA) license. Map data from OpenStreetMap and its

contributors, used under the Open Data Commons Open Database License (ODbL).

This book would not exist without the love and contribution of my wonderful wife, Jennie. Thank you for all your ideas, support and sacrifice to make this a reality. Hello to our terrific kids, Redford and Roxy.

Thanks to the many people who have helped PhotoSecrets along the way, including: Bob Krist, who answered a cold call and wrote the perfect foreword before, with his wife Peggy, becoming good friends; Barry Kohn, my tax accountant; SM Jang and Jay Koo at Doosan, my first printer; Greg Lee at Imago, printer of my coffe-table books; contributors to PHP, WordPress and Stack Exchange; mentors at SCORE San Diego; Janara Bahramzi at USE Credit Union; family and friends in Redditch, Cornwall, Oxford, Bristol, Coventry, Manchester, London, Philadelphia and San Diego.

Thanks to everyone at distributor National Book Network (NBN) for always being enthusiastic, encouraging and professional, including: Jed Lyons, Jason Brockwell, Kalen Landow (marketing guru), Spencer Gale (sales king), Vicki Funk, Karen Mattscheck, Kathy Stine, Mary Lou Black, Omuni Barnes, Ed Lyons, Sheila Burnett, Max Phelps and Les Petriw. A special remembrance thanks to Miriam Bass who took the time to visit and sign me to NBN mainly on belief.

The biggest credit goes to you, the reader. Thank you for (hopefully) buying this book and allowing me to do this fun work. I hope you take lots of great photos!

© Copyright

PhotoSecrets Washington DC, first published April 15, 2019. This version output March 4, 2019.

ISBN: 978-1930495630. Distributed by National Book Network. To order, call 800-462-6420 or email customercare@nbnbooks.com.

> *"'And what is the use of a book,' thought Alice*
> *'without pictures or conversations?'"*
> *— Alice's Adventures in Wonderland, Lewis Carroll*

© Copyright

✎ Disclaimer

The information provided within this book is for general informational purposes only. Some information may be inadvertently incorrect, or may be incorrect in the source material, or may have changed since publication, this includes GPS coordinates, addresses, descriptions and photo credits. Use with caution. Do not photograph from roads or other dangerous places or when trespassing, even if GPS coordinates and/or maps indicate so; beware of moving vehicles; obey laws. There are no representations about the completeness or accuracy of any information contained herein. Any use of this book is at your own risk. Enjoy!

✉ Contact

For corrections, please send an email to andrew@photosecrets.com. Instagram: photosecretsguides; Web: www.photosecrets.com

▪▪ Index

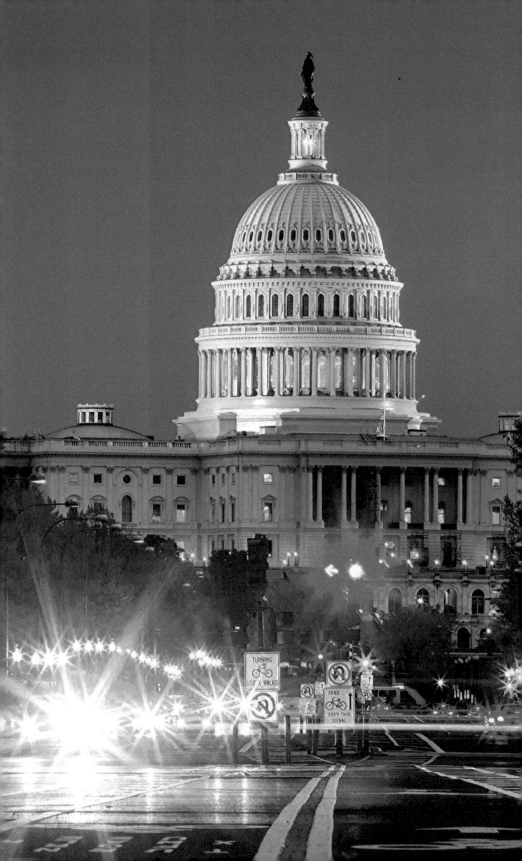

THANK YOU for reading PhotoSecrets. I like to start books by flicking from the back cover, so this is a good place for a welcome message.

As a fellow fan of travelling with a camera, I hope this guide will quickly get you to the best spots so you can take postcard-perfect pictures.

PhotoSecrets shows you all the best sights. Look through, see the classic shots, and use them as a departure point for your own creations. Get ideas for composition and interesting viewpoints. See what piques your interest. Know what to shoot, why it's interesting, where to stand, when to go, and how to get great photos.

Now you can spend less time researching and more time photographing.

The idea for PhotoSecrets came during a trip to Thailand, when I tried to find the exotic beach used in the James Bond movie *The Man with the Golden Gun*. None of the guidebooks I had showed the beach, so I thought a guidebook of postcard photos would be useful. Twenty-plus years later, you have this guide, and I hope you find it useful.

Take lots of photos!

Andrew Hudson

Andrew Hudson started PhotoSecrets in 1995 and has published 18 nationally-distributed color photography books. His first book won the Benjamin Franklin Award for Best First Book and his second won the Grand Prize in the National Self-Published Book Awards.

Andrew has photographed assignments for *Macy's, Men's Health* and *Seventeen*, and was a location scout for *Nikon*. His photos and articles have appeared in *National Geographic Traveler, Alaska Airlines, Shutterbug, Where Magazine*, and *Woman's World*.

Born in England, Andrew has a degree in Computer Engineering from the University of Manchester and was previously a telecom and videoconferencing engineer. Andrew and his wife Jennie live with their two kids and two chocolate Labs in San Diego, California.